JIM CHURCH'S
ESSENTIAL GUIDE TO

NIKONOS SYSTEMS

D0125389

AQUA QUEST PUBLICATIONS, INC. ■ NEW YORK

Library of Congress Cataloging-in-Publication Data

Church, Jim.
 [Essential guide to Nikonos systems]
 Jim Church's essential guide to Nikonos systems / Jim Church
 p. cm.
 Includes index.
 ISBN 1-881652-04-1 : $22.95
 1. Nikonos camera—Handbooks, manuals, etc. 2. Underwater
 photography—Handbooks, manuals, etc. I. Title. II. Title:
 Essential guide to Nikonos systems.
TR263.N5C44 1994
778.7'3—dc20 94-15325
 CIP

Cover: Jeannie Wiseman inspects the bridge of the sunken *Shinkoku Maru* in Truk Lagoon. I photographed her with a Nikonos RS and 20-35mm zoom lens set for the 20mm wide-angle setting. The exposure was f5.6 at 1/125 second on Fujichrome 100 RDP Professional film. I used twin Nikon SB-101 Speedlights set for TTL with wide-angle diffusers.

All photographs are by the author unless credited otherwise.

Printed in Hong Kong
10 9 8 7 6 5 4 3 2 1

Design by Chris Welch.

••• ACKNOWLEDGEMENTS •••

I thank the many persons who read rough drafts, gave advice, posed for photos and contributed photos for this book. They are (in alphabetical order): Tom Adam, Stewart Bakst, Gerald Freeman, Mike Haber, Randy McMillan, Ken McNeil, Mike Mesgleski, Kathy Rutt, Clay and Jeannie Wiseman, and Tabby Stone. I also want to thank the world's most patient publisher, Tony Bliss, of Aqua Quest.

No manufacturer or distributor of underwater photographic equipment has seen this text before publication. However, I wish to thank Frank Fennell, Kathy Lawless and Scott Frier, all of Nikon, for providing technical information.

J.C.

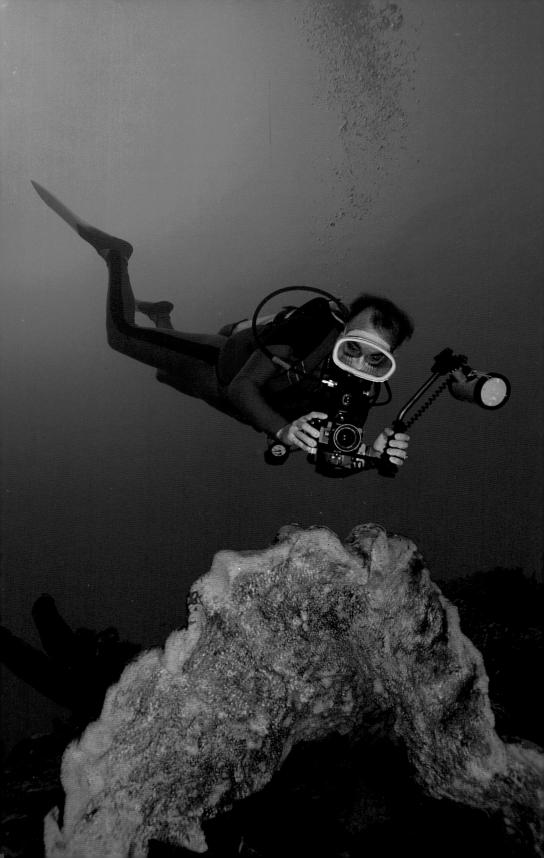

··· CONTENTS ···

PART
1
INTRODUCTION

PART
2
BACK TO THE BASICS

P A R T
3

ALL ABOUT STROBES

PART
4

HOW TO USE THE NIKONOS V

P A R T
5

How to Use the Nikonos RS

PART
6

MAINTAINING YOUR EQUIPMENT

PART
7

APPENDICES

··· FOREWORD ···

Dear Reader,

Before loading your new camera and jumping into the water to take underwater pictures, please read the following seven steps for mastering underwater photography. Those of you with an artistic flair may balk at following a list of steps. However, consider this: Steps 1 to 6 will free you from mechanical and situational roadblocks so you can unleash your artistic talents in Step 7.

Step 1: Master diving skills. You must learn to control your body underwater before trying to control a camera.

Step 2: Learn the camera system parts. Learn the names, position and function of every part and control. As examples, where are the aperture control, the on/off switch and the LED displays?

Step 3: Learn to operate camera system controls by feel. Can you find any f-stop by counting the click stops, or turn your strobe to TTL or any power setting by feel?

Step 4: Develop underwater situational awareness. What conditions will you face? Will you be photographing in bright or dim conditions, in clear or turbid water? Will you have moving or stationary subjects?

Step 5: Decide on a reasonable goal that fits the situation. If the water is too turbid for scenics, you might select close-up photography as your goal.

Step 6: Apply the correct photographic technique. The situation and goal dictate the proper technique. The techniques are presented, step-by-step, in this book.

Step 7: Compose and take beautiful underwater photographs. This is the payoff. This is the purpose of this book.

My Best Wishes,

Jim Church

PART
··· *1* ···
INTRODUCTION

··· *1* ···

READ ME FIRST

"If all else fails, read the directions." This old adage applies to this introductory chapter; it will help you get the most from this book.

THE PURPOSE OF THIS BOOK

The purpose of this book is to help you master the Nikonos V camera and the Nikonos RS (reflex system). The information and situations presented assume that you are using Nikon lenses and Nikon strobes. *However, the same principles and techniques apply to non-Nikon equipment as well!*

We will go beyond the information provided in the Nikon owner manuals. Therefore, much of the information already covered in those manuals, such as nomenclature and specifications, has been omitted in this book. Some information, of course, must be repeated so clear explanations can be presented.

• • • ——————————————————————————

I will assume that you have read the owner's manuals for all of your photographic equipment. Don't worry, you don't have to understand everything. That's why you're reading this book.

—————————————————————————— • • •

FIND YOUR RECIPE

Think of this text as a cookbook. Scan the extended table of contents. Decide what photo situation you wish to master, and then look up and apply that specific technique (recipe).

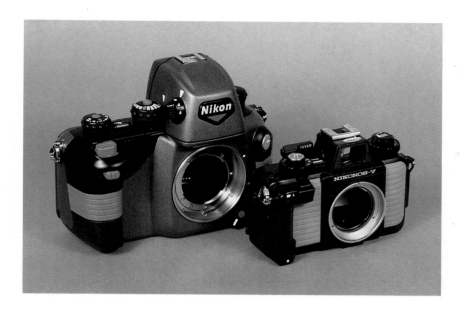

The Nikonos RS (left) and Nikonos V (right) are the only Nikonos camera bodies in current production. The Nikonos RS is the more expensive camera body, offering SLR viewfinding and focusing, center-weighted and matrix exposure metering, and TTL (through-the-lens) flash exposure control. The Nikonos V is a smaller, simpler camera body. It has both manual and automatic exposure modes for sunlight exposure control and TTL strobe exposure control. The Nikonos V is the standard to which all other 35mm underwater cameras (amphibious or housed) are compared to.

Centered Headlines, "Situations" and Italics

Three formats are blended to help you find and utilize information: centered headlines, "situation" headlines, and text in italics.

- Centered headlines present general and background information.
- Centered "situation" headlines present specific techniques for specific underwater situations. *These are the recipes.*

- Italic sections present supplemental information and author's comments that support centered headlines.

Nikonos Family History

Although this book is about using the Nikonos V and Nikonos RS, let me briefly sum up Nikonos camera development.

●●● ───────────────────────────

The following section almost brings a tear to my eye. I own and have used and taught with the Calypso and every model of Nikonos from the Nikonos I to the Nikonos RS.

─────────────────────────── ●●●

The **Calypso** amphibious 35mm camera was the beginning. Invented by Jacques Cousteau and Jean De Woutersk, it was first marketed in France in 1958. It later became the **Calypso-Nikkor.**

The **Nikonos I** followed the Calypso-Nikkor and was marketed by Nikon from 1962 to 1968. The designation "Nikonos I" wasn't official. Rather, it was called that after the Nikonos II and later models were introduced. The **Nikonos II**, an improved version of the Nikonos I, was marketed from 1968 to 1975.

●●● ───────────────────────────

The Calypso, Nikonos I and II were sturdy little cameras. Flashbulb units were introduced first, then several companies introduced housings for strobes. The flash sockets of these three cameras are not compatible with present day strobe connectors, but some repair services can update flash connections. One major problem with these early cameras was that spacing between film frames was often erratic.

─────────────────────────── ●●●

The **Nikonos III**, marketed from 1975 to 1980, was a great improvement over the earlier models. The film advance was no longer erratic, and a new three-pin flash socket was introduced. This flash socket is compatible with present day strobe cord connectors for manual exposure control. Being a mechanical

camera with no batteries or electronics, the Nikonos III is still the camera of choice for some photographers who shun new-fangled, delicate electronics. A flooded Nikonos III was easily rinsed, dried and returned to service.

The **Nikonos IV-A** was (in my opinion) a dud. It had a simplified automatic exposure control that didn't indicate the shutter speed. All you saw in the viewfinder display was a dot that glowed if the shutter speed was less than 1/1000 second or greater than 1/30 second. Nikon also introduced their first underwater strobe, the **SB-101**. It had a remote sensor that mounted on the accessory shoe on top of the Nikonos IV-A camera body. The sensor only allowed two choices of aperture for automatic exposure control. Balancing sunlight and strobe was difficult because you couldn't conveniently determine the sunlight aperture. The Nikonos IV-A was produced from 1980 to 1984.

The **Nikonos V**, introduced in 1984, is still in production and is the most commonly-used amphibious camera at this writing. The Nikonos V has two built-in automatic exposure control systems: one for metering sunlight exposures, and one for controlling a TTL strobe. Two strobes, the **SB-102** (1984) and **SB-103** (1985) were introduced for use with the Nikonos V.

The **Nikonos RS (Reflex System)** was introduced in 1992. It is a SLR (single-lens reflex) camera with electronic exposure controls for manual, automatic and TTL exposures. The Nikonos RS is compatible with the SB-102, SB-103, and the new **SB-104** strobes. Lenses for the RS are not compatible with any other Nikonos camera body.

●●●
The Nikonos RS isn't a replacement for the Nikonos V. At this writing, Nikon sees the two cameras as a two-level product line because the Nikonos RS is substantially more expensive than the Nikonos V. The Nikon SB 102, 103 and 104 strobes can be used with either the Nikonos V or Nikonos RS.
●●●

··· 2 ···

Underwater Photography Is Different

A topside photographer can sit on a log, puff his pipe and contemplate Ansel Adam's zone system. He can mount his camera on a tripod and wait for the setting sun. Underwater, however, things will be drastically different.

You're in the Water Now

Let's be honest. If you're flailing around in the water and need both hands just for diving, you're not ready to take pictures. Neutral buoyancy and body control are your first learning goals.

You should be able to remain virtually motionless in the water. When you inhale, you should start to rise (but be careful not to embolize). When you exhale, you should start to sink. To master neutral buoyancy, start with two drills: the sky diver and the crossed fins position. Start by mastering these drills without holding a camera system. Then, do the drills with your camera in hand.

The sky diver position. At about 20 feet, place your body in a prone position, with legs slightly apart and with your arms extended. Assume the "sky diver" position you've seen parachutists use on TV. Put just enough air in your BC to maintain your position.

The crossed arms and fins position. At your working

depth, assume an upright position then cross your arms and fins. You should be able to maintain this position and depth for several seconds.

When you do the above drills while holding your camera system, you may need to remove one or two pounds of lead. Holding a Nikonos V with 15mm lens and twin strobes, for example, is like holding a two-pound lead weight.

KILLER NECKSTRAPS AND LANYARDS

In my opinion, neckstraps and tight-fitting lanyards aren't safe for you, your dive buddy or your Nikonos. If you can't get free of the camera during an emergency, you could drown, and your buddy could drown while attempting a rescue. You should be

Having practiced the "skydiver" position, Mike Mesgleski can comfortably hover in midwater. If you must kneel on the bottom, choose a sand patch. Please don't kneel on fragile corals.

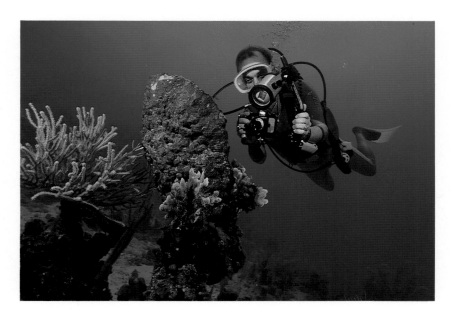

In addition to damaging marine life, some thoughtless divers vandalize artifacts, such as the port wing of a Betty bomber in Truk Lagoon, with graffiti.

able to drop everything at once! In shallow water, you can retrieve your camera later. If you are diving over a 3,000 foot wall, however, you may want a safety lanyard. If so, be sure you can slip your hand out of the lanyard easily.

Warning: Because a camera system can weigh two or three pounds underwater, vent air from your BC immediately if you must jettison the camera! Otherwise, you could rise and embolize.

I've seen dozens of dangling cameras and strobes scarred or damaged as they impacted hard coral and the rungs of boat ladders. Hold your camera system by hand; don't let the system dangle below you on a cord or neckstrap.

Don't Jump with the Camera

I've seen several photographers jump from dive platforms and docks while holding their camera systems. The impact of the camera striking the surface can damage camera equipment. I've seen viewfinders sheared off. I've seen Sekonic Marine Exposure Meters jam. I've seen partial floods when lens O-rings momentarily lost their watertight seals upon impact. I've seen lots of bad stuff happen!

The best technique is to have someone hand you your camera after you jump in, and take it back after the dive. If you can't get help and the dive platform is low, place the camera at the edge of the platform. Jump in and then reach for the camera. A technique I often use is to kneel on the platform, lower the camera into the water with one hand, then roll off the platform.

If you use a down line (a line attached to the camera), be sure that you devise a way to attach the line to the camera so the strobe won't detach. Be sure to check the depth of the water when you lower the camera. (You don't want it to strike bottom in shallow water.) But most important of all, don't forget to pull the camera out of the water before they move the boat!

Don't Wreck the Reef

A few underwater photographers give all of us a bum rap. They will do anything to get the picture, including kneeling on fragile corals. In the early days, I've seen photographers actually wear knee pads. Use your neutral buoyancy to hover rather than kneel on coral. In the absence of current, you should be able to maintain your position with just a thumb and first finger holding on to a rock or other non-living object.

Apparent Distances

You swim to the anchor line and reach for it, but your arm seems to be too short. You can't reach the line although it is right in front of your face! This is a prime example of *apparent distance*. Underwater objects (such as the anchor line) are actually one third further away than they appear to your eye. In other words, an object that appears to be three feet away (its apparent position) is actually four feet away (its actual position).

●●● ———————————————————————————

Nikonos lenses "see" apparent distances. As long as you estimate the apparent distance accurately by eye, and set the focus control for that estimated apparent distance, the focus will be correct.

——————————————————————————— ●●●

Loss of Sunlight

As sunlight passes down through the water, some light is

absorbed and converted into heat. Light is also reflected and blocked by suspended particles in the water. Bright particles reflect light, and dark particles block its passage.

Thus, in average Caribbean conditions, you can expect to lose about one or two f-stops of light just below the surface, and about one stop for each ten to fifteen feet of depth. There are lots of exceptions, of course. A cloudy sky, low-angle sun or turbid water increases light loss. A clear sky, overhead sun, clear water or reflective sand bottom reduces light loss.

LOSS OF COLOR

Colors are lost as light rays are selectively absorbed while passing through water. Reds disappear in the first 20 feet. At about 30 to 40 feet, say good-bye to orange. Yellow lingers to about 60 or 70 feet. At about 100 feet or more, welcome to the land of blue haze. You will need strobe lighting at close distances to restore lost colors. The techniques of using strobes will be presented later in this book.

SQUEEZE AND BE SURPRISED

It is important that you hold the camera as steady as possible at the moment you take a picture. Don't punch the shutter release! Squeeze the shutter release gently. Although you know that the shutter will be released, the exact moment the shutter is released should be a surprise to you. If you punch the shutter release, you will cause camera movement which blurs pictures.

MAINTENANCE IS CRITICAL

Just because the maintenance chapters are at the end of the book doesn't mean that these chapters are not important. Because you will be taking your camera equipment underwater (and especially if you dive in seawater), maintenance is critical. A flooded camera can ruin the best of diving days.

PART
··· 2 ···

BACK TO
THE BASICS

··· 3 ···

WHAT THOSE
FUNNY TERMS
AND NUMBERS MEAN

Photography is cursed with bunches of terms and numbers with funny names and confusing meanings. The purpose of this chapter is to make some of these terms and numbers more understandable.

HOW MANY COWS PASS THROUGH THE GATE?

Imagine that you are moving a herd of cattle through a gate, from one pasture to another.

- If you open the gate wide (a wide aperture), a large number of cattle can pass through the gate at the same time.
- If you only open the gate partway (a narrow aperture), fewer cows can pass through.

Let's apply the "cows through the gate" idea to a lens aperture control. A wide aperture setting allows more light to pass through the lens; a narrower aperture setting allows less light to pass through the lens. Thus, we can regulate the amount of light passing through the lens by varying the width of the aperture. *This, in the simplest terms, is what the aperture control does.*

APERTURE AND F-STOPS

Stop reading and get a camera lens. With lens in hand, do

each of the following experiments as you read each step:

1. Set the aperture for f22. Look at the size of the aperture.
2. Set the aperture for f16. See how the aperture opens. The wider aperture (diameter) at f16 allows twice as much light to pass through the lens as f22.
3. Continue opening the aperture to each lower-number f-stop. Each time you open the aperture by one f-stop, twice as much light can pass through the lens.
4. Now, start at f4 and close to each higher-numbered f-stop. Each time you close the aperture to the next higher-numbered f-stop, the amount of light that can pass through the lens is halved.

Consecutive Full F-Stops

Changing from one consecutive f-stop to the next lower-numbered f-stop doubles the amount of light passing through the lens. Changing from one consecutive to the next higher-numbered f-stop halves the amount of light passing through the lens. F-stops that have this relationship are called *consecutive full f-stops*.

The consecutive, full f-stops most commonly used are: f2.8, f4, f5.6, f8, f11, f16, f22 and f32. Not all camera lenses have the full range of full stops. In some cases, the widest aperture may be a fractional f-stop. As examples, f2.5 on the Nikonos 35mm lens and f3.5 on the Nikonos 28mm lens are fractional f-stops.

Fractional (Partial) F-Stops

Fractional (partial) f-stops are the "unseen" f-stops that are between the f-stops shown on the aperture scale of the lens.

Nikonos V. Yes, you can set the aperture between the f-stops marked on the lens aperture scale. In writing, a fractional f-stop between f8 and f11 is expressed as f8-11. With a Nikonos V lens, you won't know the f-numbers of partial f-stops, but it really doesn't matter. *The key idea is that you can select apertures between the f-stops marked on the aperture scale.*

Nikonos RS. The RS aperture dial is marked for f2.8, f4, f5.6, f8, f11, f16 and f22. These are consecutive full f-stops. The dots between these f-numbers are for partial stops between the full stops. Starting at f2.8, look into the viewfinder as you rotate the aperture control knob. You will see the full and partial stops in this order: f2.8, f3.3, f4, f4.8, f5.6, f6.7, f8, f9.5, f11, f13, f16, f19 and f22.

FOCAL LENGTH

Focal length is the distance (in millimeters) from a point near the optical center of the lens to the surface of the film. The focal lengths for Nikonos V lenses are 15mm, 20mm, 28mm and 35mm. The Nikonos RS lenses have focal lengths of 20-35mm zoom, 28mm and 50mm.

To sum up, the shorter the focal length, the wider the picture angle of the lens. The longer the focal length, the narrower the picture angle of the lens.

FOCAL LENGTH AND F-STOPS

A specific f-stop is determined by dividing the diameter of the aperture into the focal length of the lens. (You don't make this calculation; the f-stops are marked on the aperture scale of the lens.)

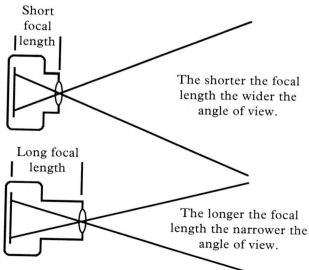

Short focal length

The shorter the focal length the wider the angle of view.

Long focal length

The longer the focal length the narrower the angle of view.

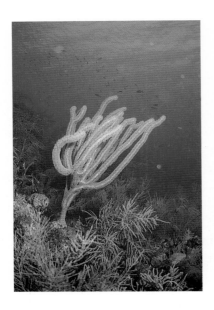

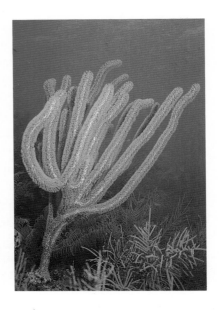

This photo was taken at two apparent feet with the RS zoom lens set for a focal length of 20 mm. Notice how the soft coral appears small and far away.

The same soft coral, also taken at two apparent feet, but with the RS zoom lens set for a focal length of 35mm. Notice that the coral appears larger and closer.

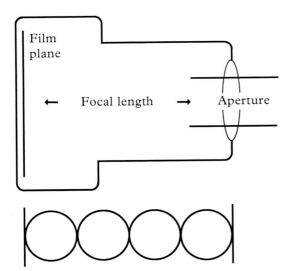

An f-stop is the number of times the diameter of the aperture divides into the focal length. This aperture divides into the focal length four times. Thus, the f-stop is f4. The four circles represent the aperture and are there to help you visualize the division of focal length by aperture.

RELATIVE AND EFFECTIVE F-STOPS

When you place an extension tube between a Nikonos V camera body and a Nikonos 35mm or 28mm lens, the distance between the lens and film is increased. This causes an interesting effect: the actual f-stop will be higher-numbered than the f-stop shown on the lens aperture scale. Why? Because the diameter of the lens aperture is divided into a greater lens-to-film distance. The f-stop shown on the lens aperture scale is the *relative* f-stop. The actual f-stop is the *effective* f-stop.

The same thing happens when you focus a Nikonos RS 50mm lens in for extreme close-ups. Because the lens moves away from the film during close focusing, the effective f-stop will have a higher f-number than the relative f-stop shown in the camera viewfinder.

CALCULATING EFFECTIVE F-STOPS

This section is for the fussy photographers who want all the details. To calculate an effective f-stop (fe), multiply the relative f-stop (fr) times the sum of the degree of magnification (m) plus a constant factor of 1.

For example, with the lens set for f22, and an image ratio of 1:2, the calculation is as follows:

$$fe = fr(m + 1) \quad \text{the formula}$$
$$fe = 22(1/2 + 1) \quad \text{substitute values}$$
$$fe = 22(1.5) \quad \text{combine terms}$$
$$fe = f33 \quad \text{solve for fe}$$

Thus, when the camera lens is set for f22 (the relative f-stop), you are actually using f33 (the effective f-stop) with a 1:2 extension tube.

WHAT EFFECTIVE
F-STOPS MEAN TO YOU

Have you ever wondered why the strobe must be held so close

when you are using an extension tube with a Nikonos V camera? It's because of the effective f-stop. For example, assume that you are using a 1:1 extension tube and set the camera for f22. The effective f-stop is f45! Thus, the strobe must be held only inches from the subject so enough light will reach the film. The same thing happens when you take extreme close-ups with the Nikonos RS 50mm lens. Understanding effective f-stops helps you understand why the strobe must be held so close.

SHUTTER SPEEDS

● ● ● ──────────────────────────────────

Remember the "cattle passing through the gate" example at the beginning of this chapter. Think of shutter speed as how long you hold the gate open.

────────────────────────────────── ● ● ●

Tom Adam used 1/125 second for this 35mm lens shot of a hammerhead shark. A faster film speed would have allowed shooting at 1/250 for a sharper image.

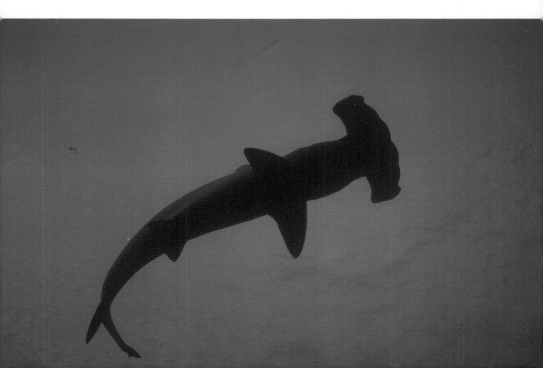

A shutter speed is simply the amount of time film is exposed to light. Each consecutive shutter speed (from fast to slow) approximately doubles the amount of light passing through the lens.

Look at your camera body and find the shutter speed settings for 1/500, 1/250, 1/125, 1/60 and 1/30 second. The Nikonos RS also has shutter speeds of 8 (1/8 second), 4 (1/4th second), 2 (1/2 second) and 1 (1 second). Both the Nikonos V and RS have a shutter speed marked "B." When set for B, the shutter stays open as long as you keep the shutter release depressed.

● ● ● ────────────────────────────────

Fast shutter speeds are used to stop fast action. With slow shutter speeds, moving subjects can cause blurry pictures because the subject was moving while the exposure was being made.

──────────────────────────────── ● ● ●

Here is the rule of thumb for estimating the slowest shutter speeds you can use with a hand-held camera. The slowest shutter speed is the speed closest to the focal length of the lens. As example, you should be able to use 1/30 of a second with a 35mm lens, or 1/100 second with a 100mm lens. See the following estimated table:

MINIMUM SHUTTER SPEEDS FOR HAND-HELD CAMERAS		
Lens Focal Length	**Minimum Speed**	**Safer Speed**
50 mm	1/60	1/125
35mm	1/30	1/60
20mm	1/30	1/60
15mm	1/15	1/30

In this book, I will consider shutter speed to be 1/60 second, unless there is a reason to select a different shutter speed. For

example, it takes 1/250 second to photograph shimmering sunbeams sharply.

Focus (Focus Control)

A lens can only focus for one distance at a time. Thus, your Nikonos lens has a *focus control* to set the lens for camera-to-subject distance. With Nikonos V cameras, you usually estimate distance by eye and set the focus control manually. With the Nikonos RS, you can use an autofocus control. When the focus control is set for the proper lens-to-subject distance, we say the lens is *in focus.*

Depth of Field

Depth of field is the area in front of the lens which will be acceptably sharp (in focus). Depth of field extends from a near point in front of the focused distance to a far point beyond the focused distance. Subjects within this depth of field zone will appear reasonably sharp in your pictures.

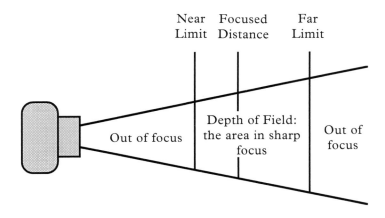

Near Focused Far
Limit Distance Limit

Out of focus Depth of Field: the area in sharp focus Out of focus

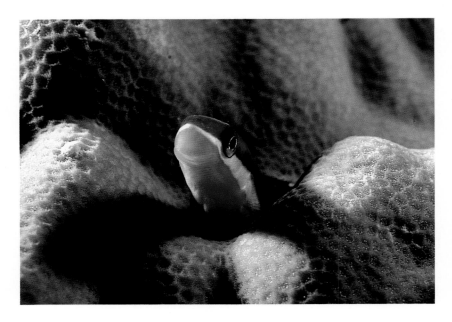

The camera lens was focused for the fish's eye. Because of limited depth of field with small picture areas, the foreground and background are not in sharp focus.

The near and far points, however, are not exact cut-off points! Loss of sharpness occurs gradually as you move away from the exact focused distance.

● ● ●　————————————————————————————————
　　One-third of the depth of field is on the near side of the subject, and two-thirds is on the far side, when the lens is focused for infinity. This ratio changes as the lens is focused closer. At a 1:1 image ratio, half the depth of field will be on the near side, and half on the far side.
————————————————————————————————　● ● ●

WHAT DETERMINES DEPTH OF FIELD

The amount of depth of field is determined by three variables: aperture, picture area and focused distance.

- The higher the f-number (smaller the aperture), the greater the depth of field. The lower the f-number (wider the aperture), the lesser the depth of field.
- The larger the picture area, the greater the depth of field. The smaller the picture area, the lesser the depth of field.
- The further the focused distance (the larger the picture area), the greater the depth of field. The closer the focused distance, the lesser the depth of field.

NIKKOR LENSES

First, let's look at the abbreviations and terminology for lenses.

- **W** = Underwater or topside use
- **LW** = Topside use, splash resistant
- **UW** = Underwater use only
- **Nikkor** = Manufacturer's trade name for glass optics
- **28mm** = Focal length of lens
- **f2.5** (or other f-stop) = Widest aperture possible with this lens
- **R-UW AF** = Reflex system, underwater use only, auto-focus lens
- **Micro** = Close focusing to 1:1
- **Zoom** = Variable focal length

For the Nikonos V camera. Four Nikon lenses are currently available. These lenses can be attached to any model Nikonos camera body from the Calypso and Nikonos I to the Nikonos V, but can't be used with the Nikonos RS.

- W Nikkor 35mm f2.5 lens
- UW Nikkor 28mm f3.5 lens
- UW Nikkor 20mm f2.8 lens
- UW Nikkor 15mm f2.8 lens

Two Nikonos lenses have been discontinued: The LW Nikkor 28mm f2.8 lens was a splash-resistant lens for topside use. The Nikkor 80mm f4 lens was designed for moderate telephoto, underwater or topside.

For the Nikonos RS (reflex system) camera. The R (reflex) lenses are designed for SLR (single-lens reflex) viewfinding. When you look into the camera viewfinder, you actually look through the lens. Your eye sees the same view that the film will "see" when the shutter is triggered.

Four lenses are currently available. These lenses can only be used with the Nikonos RS.

- R-UW AF Micro Nikkor 50mm f2.8 lens
- R-UW AF Nikkor 28mm f2.8 lens
- R-UW AF Zoom-Nikkor 20-35mm f2.8 lens
- R-UW AF Fisheye 13mm f2.8 lens

··· 4 ···

FILMS AND EXPOSURE

Recommending specific brands of film is difficult. No sooner do you write the book, than the manufacturers change film specifications and names. Even as I write this chapter, I hear rumors of new films that will appear on the market.

FILMS, CHROME AND COLOR

M ost underwater photographers use color slide film. Color slide films end with the word, "chrome." Examples of ASA include Fujichrome 50 and Ektachrome 100. Color print (color negative) films end with the word "color." Examples include Fujicolor 100 and Ektacolor 100.

Many dive resorts and live-aboard dive boats offer overnight color slide processing for most color slide films. These include Ektachromes, Fujichromes and other color slide films with the words "process E-6" on the carton. Kodachromes can't be processed with E-6 chemistry. You must take Kodachromes home and send them to photo processing labs that accept Kodachrome.

● ● ● ───
Many resort locations offer one-hour or one-day developing and printing for color print films. At this writing, I know of no live-aboards that offer this service.
───────────────────────────────────── ● ● ●

ASA AND ISO FILM SPEEDS

The film speed number indicates how much light the film requires for the exposure. A high-speed film (fast film) requires less light for an exposure. Thus, fast films are often used in dim

conditions. A slow-speed film (slow film) requires more light for an exposure. Thus, slow films are used in bright conditions.

● ● ● ───────────────────────────────

Here's a simple way to visualize film speeds: Given a constant f-stop, a fast film requires a faster shutter speed than a slow film. Because the fast film is more sensitive to light, the exposure is made faster.

─────────────────────────────── ● ● ●

The ASA (American Standards Association) and ISO (International Standards Organization) film speed ratings use the same system of film speed numbers to indicate fast and slow film speeds. The higher the number, the faster the film. The lower the number, the slower the film. Film speed numbers are usually included in the names of films, such as Ektachrome 100, Fujichrome 50 and Kodachrome 64.

● ● ● ───────────────────────────────

Older books use ASA numbers to express film speeds. Newer books usually use ISO numbers. Some books and camera manuals use both, combining ASA and ISO as ASA/ISO. Thus, ASA, ISO and ASA/ISO film speed numbers all have the same meaning. I will use ISO numbers in this book.

─────────────────────────────── ● ● ●

Consecutive Film Speeds

Each time the film speed rating is doubled, the film needs half as much light for an exposure. As examples, ISO 400 film needs half as much light as ISO 200 film, and ISO 200 film needs half as much light as ISO 100 film.

The film speeds shown in the first column (reading down) are the consecutive film speeds found on the film speed dials of most cameras. Each consecutive film speed (from 25 to 50, and so on down the line) means that the film will require half as much light for an exposure. The one-third and two-thirds film speeds are the film speed values for the dots shown between the film speed numbers shown on the dial.

CONSECUTIVE ISO FILM SPEEDS		
Full	**One-Third**	**Two-Thirds**
25	32	40
50	64	80
100	125	160
200	250	320
400	500	650
800	1000	1250
1600	2000	2500

ISO 64 film captured the fine details of the encrusting growth on these Japanese machine gun bullets in the hold of the Sankisan Maru *in Truk Lagoon.*

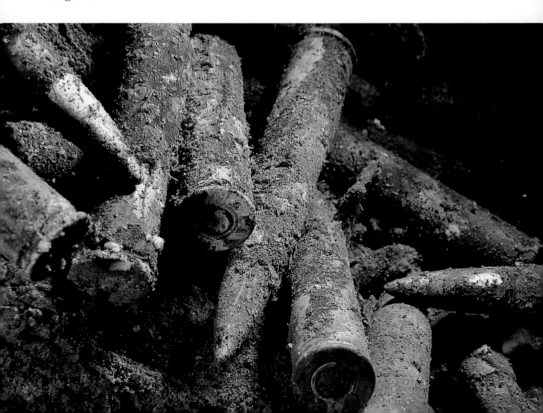

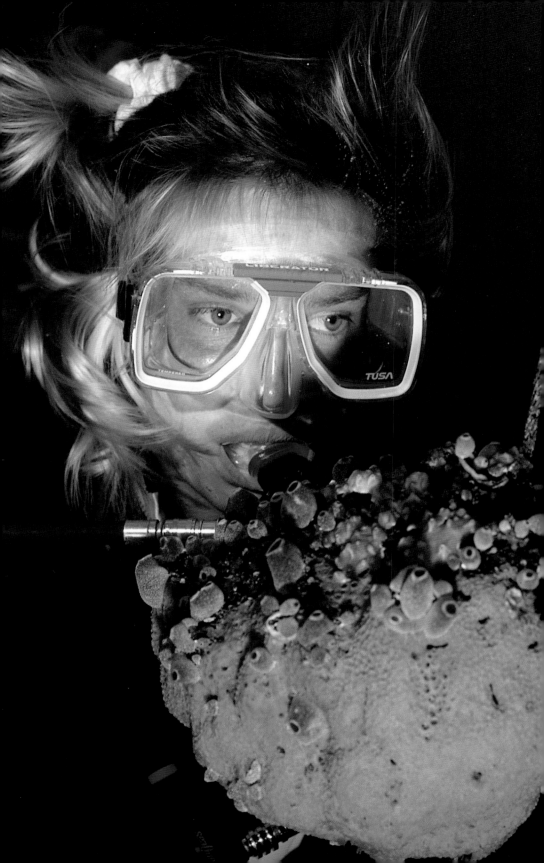

● ● ● ───────────────────────────────

Film manufacturers usually double the ISO film speed when manufacturing films for different lighting conditions. Some examples are: ISO 25, 50, 100, 200 and 400. The main exceptions are Kodachrome 64 and Ektachrome 64.

─────────────────────────────── ● ● ●

CHOOSING A FILM SPEED

Slow films usually have a finer grain structure than fast films. Thus, images are sharper. Colors are brighter and more contrasty. The increased contrast reduces exposure latitude—the amount of over- or underexposure the film will tolerate.

Slow films (ISO 25 to 64) are best for close-up and extension tube photography. Many close-up subjects have fine details, and the finer grain of slow films captures these details better. Slow films require more light for an exposure than do fast films, but the strobe is close enough to the subject to provide adequate light.

Medium-speed film (ISO 100) is my favorite "general purpose" film. This is what I recommend to students who wish to standardize with one film speed. You can use this film speed for close-ups, normal-angle or wide-angle, in most situations.

Fast films (ISO 200 and above) are used when low light levels would cause you to use slower shutter speeds or wider apertures (lower-numbered f-stops). I use fast films for wide-angle scenic views in dim conditions. For example, I might use ISO 400 to photograph an engine room of a sunken ship.

To summarize, I use ISO 50 and 64 for close-up work and wide-angle in bright conditions. I use ISO 100 for normal and wide-angle lenses, from 35mm to 15mm, in average sunlight. I use ISO 400 for scenics in dim conditions, or if I need fast shutter speeds to stop fast action.

The following chart summarizes the uses of various film speeds.

I chose an ISO 64 film for Jeannie Wiseman's portrait and focused for her face. ISO 100 film would have been a better choice because the increased depth of field would have made the yellow sponge appear sharper.

USES FOR VARIOUS FILM SPEEDS			
ISO	**Speed**	**Latitude**	**Use**
25-64	Slow	1/3 Stop	Macro & Close-Up
100	Medium	1/2 Stop	General Purpose
200-400	Fast	1/2 Stop	Normal & Wide-Angle
800+	Very Fast	2/3 Stop	Normal & Wide-Angle

★The exposure latitude estimates are subjective, based on how my eye sees proper exposure.

● ● ●

If 16 x 20-inch color prints (from color slides) are your goal, I suggest ISO 64 or slower films. For slide projection, the faster films give you greater depth of field for your scenics, and the increased grain isn't as noticeable during projection.

● ● ●

Exposure Values (EV Numbers)

Let's define exposure value (EV) with the following examples:

- The difference between two consecutive shutter speeds equals one EV.
- The difference between two consecutive full f-stops equals one EV.
- The difference in sensitivity to light between two consecutive ISO film speeds equals one EV.

For this interior view of the submerged engine room of the Cartanser *off St. Thomas, USVI, I chose ISO 400 film for the natural light exposure.*

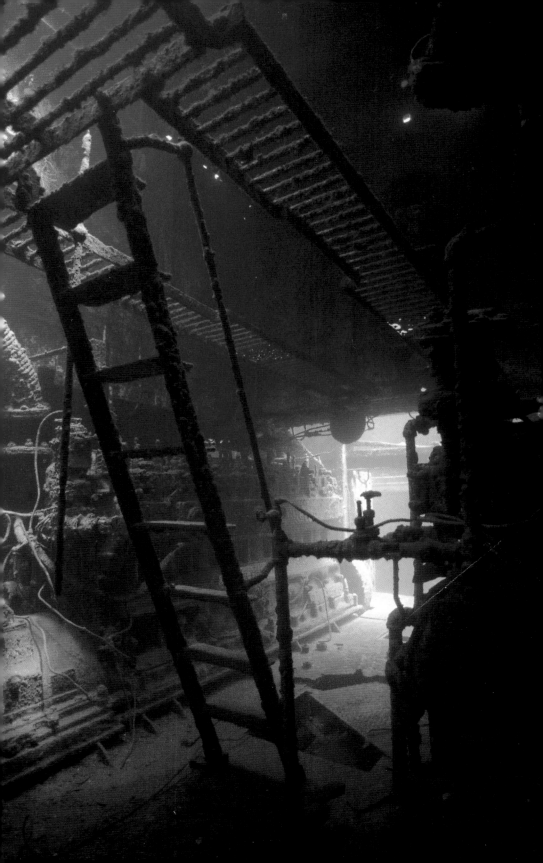

● ● ● ────────────────────────────────

To sum up, the amounts of change in exposure value between
changes in consecutive f-stops, shutter speeds or ISO films speeds
are the same: one EV.

──────────────────────────────── ● ● ●

How EV Numbers Affect You

A basic understanding of EV numbers helps you understand
camera controls and owner's manuals as follows:

- Camera manuals often use EV numbers in charts show-
 ing aperture and shutter speed combinations.
- Exposure compensation dials are usually marked in 1/3
 EV (1/3 f-stop) increments.
- The accuracies of exposure meters are often specified as
 being "plus or minus 0.5 EV." This means, "plus or
 minus one-half f-stop."

Bracket, Bracket and Bracket

In addition to variations in the accuracies of exposure meter-
ing systems, the accuracies of ISO ratings also vary. For example,
the ISO rating of color slide film can vary plus or minus one-third
EV from the designated ISO film speed. ISO 100 film, for
example, could vary from ISO 80 to ISO 125. (Professional films
are usually within one-sixth EV.)

Your best defense is to bracket exposures. For example, if you
believe that f8 is the correct exposure, take three bracketed
exposures. Shoot at f5.6, f8 and f11. One of these should be
within a half stop of the correct exposure. I use professional films
and bracket with half stops or one-third stops because (to my
eye) the latitudes of color slide films are so narrow.

Exposure Meters Love Gray

This section will be easier to understand if you will think in

terms of black & white film. Then, once you have the basic ideas, you can mentally transpose these ideas to color films.

An exposure meter "thinks" everything in the world should be average gray (what Kodak calls "18 percent gray"). As you think through the drawing shown below, assume that you are using a Nikonos V in the A (auto) mode. You have selected an aperture of f5.6, and the automatic exposure control selects the shutter speed. The panel below each fish represents the shutter speed LED display in the viewfinder. It shows the shutter speed selected to expose the fish for an average gray image in film. In each case, assume that the fish fills the sensing area of the camera's exposure meter.

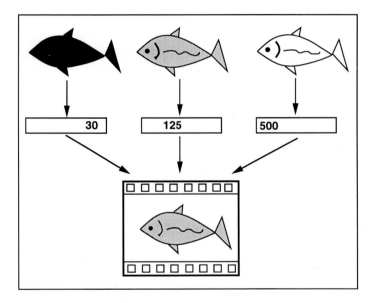

- **Left fish**. Aim the camera at a black subject, and the shutter speed slows to lighten the dark subject to average gray.
- **Center fish**. Aim the camera at an average gray subject, and the shutter speed selected keeps the average gray subject gray.
- **Right fish**. Aim the camera at a white subject, and the shutter speed increases to darken the white subject to average gray.

For the best exposure with color film, aim the meter at an area within the picture that would be gray in a black & white picture. This will keep white subject areas white, black subject areas black and gray subject areas average gray.

● ● ● ───────────────────────────

Topside photographers often meter off a standard 18 percent gray card. Others meter off the unshaded palm of their hand and then open the aperture by one f-stop. (The palm reflects one stop more light than an 18 percent gray card; thus, the one-stop adjustment.)

─────────────────────────── ● ● ●

THE GRAND TRADEOFF

Changing the ISO film speed, shutter speed or f-stop involves a tradeoff with one or both of the other exposure controls.

- A high ISO film speed may allow high shutter speeds or high-numbered f-stops, but at the cost of increased grain and poorer colors.
- A high shutter speed may force you to use lower-numbered f-stops. You gain the ability to freeze fast action at the expense of depth of field.
- High-numbered f-stops increase depth of field, but force you to use slower shutter speeds or faster ISO film speeds.

● ● ● ───────────────────────────

Each time you gain in one area (finer grain, freezing fast action or greater depth of field), you lose in one or both of the others. As they say, "There ain't no such thing as a free lunch."

─────────────────────────── ● ● ●

PART
··· 3 ···
ALL ABOUT STROBES

··· 5 ···

UNDERSTANDING UNDERWATER STROBES

Strobes are often called "flash units," "electronic flash units" or "speedlights." While strobes of different manufacturers may offer special features, all strobes are essentially the same.

HOW STROBES WORK

Without getting technical, let's begin with an overview of how a strobe works:

1. The battery supplies the electrical power.
2. The capacitor draws electrical power from the battery and stores it up for the flash.
3. The ready light turns on when the capacitor has accumulated enough electrical energy to power a flash.
4. When the strobe is triggered, the energy stored in the capacitor flows to the flashtube in one quick burst.
5. The flashtube fires a brief flash of light.

A strobe is necessary to highlight colors and details, especially at close distances.

Flash Duration

The flash duration is quite brief. As examples, with the Nikon SB-104, the flash duration is approximately 1/1000 second at manual full power, 1/1800 second at 1/4 power and 1/7000 at 1/16 power. TTL flash durations will be less than 1/1000 second.

Recycle Time

The recycle time is the time necessary for the strobe's capacitor to store up enough electrical energy to power a flash. Recycle time may be only a couple of seconds, or may be 15 seconds or more if powered by weak alkaline cells.

Nicad batteries provide short recycle times right up to the point of exhaustion. With alkaline cells, recycle time gets longer and longer as the cells wear out.

Ready Light

The ready light turns on when the capacitor is charged with electricity. The strobe is recycled. However, most ready lights turn on before the capacitor has been 100 percent charged. This is because the capacitor accepts a charge at a slower and slower rate during the recycle time. For example, the capacitor may power a flash after a six-second recycle, but may take 30 seconds to charge to 100 percent capacity for a full-power flash. Therefore, I often wait a few seconds after the ready light turns on before triggering the strobe.

● ● ● ————————————————————————————————

Modern strobes are wired to turn on a second ready light in the Nikonos V and RS viewfinders. When TTL is used, this ready light blinks after the strobe has delivered a full-power flash.

———————————————————————————————— ● ● ●

Beam Angles and Diffusers

The beam angle must cover the central picture area seen by the camera lens. If not, the picture will be brighter in the center than at the edges. Beam angle specifications are usually based on the light in the center of the beam. The light intensity at the edge of the beam may be a full stop less than at the center.

Detachable accessory diffusers widen the beam angles of some strobes. Diffusers not only widen the beam, but soften the light because light rays are criss-crossing within the beam. Nikon diffusers for the SB-102 and SB-103 also lower the color temperature of the light; this tends to make color pictures appear "warmer." Diffusers reduce the light output of the strobe by about one f-stop because the light spreads over a larger area, and the diffuser blocks some light.

• • •

Nikon diffusers are recommended for wide-angle lighting with the SB-102 and SB-103, when used with 20mm and 15mm lenses.

• • •

Some strobes (such as some Ikelite Substrobes) have adjustable beam angles for normal and wide-angle photography.

Power Settings

Some strobes have power settings for full, 1/4 and 1/16 power. Others have settings for full and 1/2 power. Each time the power setting is halved—such as from full to half power—the light emitted by the strobe is reduced by one f-stop. Starting with full power as a base, reducing the power setting reduces light output as follows:

Full power provides the total light output.
Half power reduces light output by one f-stop.
Quarter power reduces light output by two f-stops.
Sixteenth power reduces light output by four f-stops.

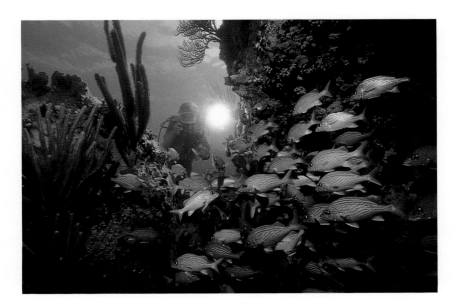

Kathy Rutt's SB-102 strobe was set for slave and 1/16 power. It flashed when the SB-102 slave sensor detected the flash of light from my strobe.

To simplify explanations, the tables and examples in this book will use full, 1/4 and 1/16 power.

SLAVE STROBES

Some strobes have a built-in slave sensor. When this sensor is turned on, the strobe is now a slave strobe. When the sensor of the slave strobe detects the flash of light from another strobe (the "master strobe") it triggers the slave strobe. The slave strobe doesn't need to be connected to the camera with a sync cord. Slave strobes are used for multiple strobe lighting.

● ● ● ─────────────────────────────────────

A slave strobe must have a built-in slave sensor. The master strobe is triggered by the camera through the sync cord. A master strobe can trigger several slave strobes, and the flash of light from one slave strobe can trigger other slave strobes.

───────────────────────────────── ● ● ●

Camera Slave Flash

A special feature of the SB-104 allows the Nikonos RS's shutter to be released when the SB-104's slave sensor detects the flash of light from another strobe. This feature is in addition to the standard slave mode.

Distress Signal Flash

Some strobes have a signal flash mode. If you're adrift and wish to make your position known, the signal flash mode triggers a weak flash every few seconds for an hour or more.

Warning Alert Lights

Some strobes have warning alert lights to warn you if the strobe's electronics are overheating, moisture has penetrated the flash unit or if a flashtube isn't firing.

Strobe Exposure and Distance

The amount of strobe light striking subjects from different distances declines in a reasonably predictable amount. Each time the strobe-to-subject distance is halved, light intensity striking the subject is increased by two f-stops. As examples, if f4 is the correct exposure at four feet, then f8 is the correct exposure at two feet; if f8 is the correct exposure at two feet, f16 is the correct exposure at one foot. Likewise, if you double the strobe distance, open the aperture two f-stops. As you can see in the following diagram, the closer the distance, the more critical the choice of aperture.

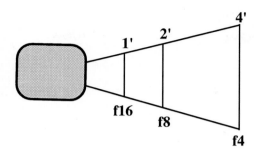

The above theory breaks down at close distances because of differences in reflector and flashtube shapes. Reducing strobe distance from one foot to six inches, for example, may be less than a two-stop difference.

A STROBE LIGHTS ONLY
ONE DISTANCE CORRECTLY

Assume that f5.6 is the correct strobe exposure for an apparent distance of three feet. Subjects closer than three feet will be overexposed; subjects at three feet will be correctly exposed; subjects beyond three feet will be underexposed.

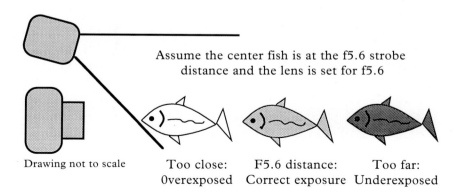

Assume the center fish is at the f5.6 strobe distance and the lens is set for f5.6

Drawing not to scale

Too close: Overexposed F5.6 distance: Correct exposure Too far: Underexposed

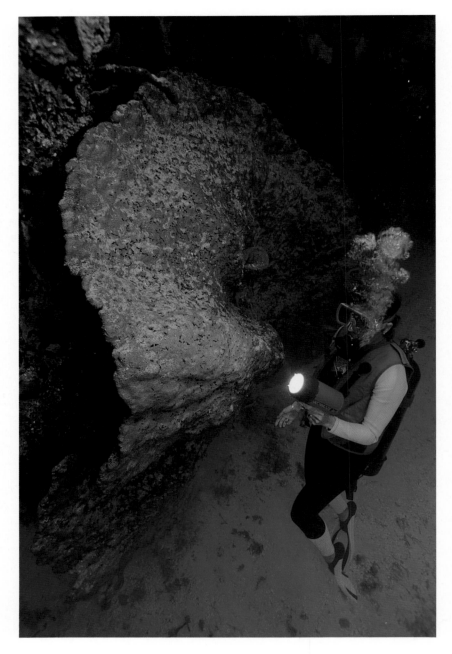

Because a strobe can only light one distance correctly, I angled my strobe from the right to illuminate the near side of the large elephant ear sponge. The far side is beyond the range of the strobe.

● ● ●

The amount of strobe light needed for a f5.6 exposure can vary. Reflective subjects, such as light skin, for example, will require less light than dark wetsuits.

● ● ●

GUIDE NUMBERS (THINK "GAD")

A *guide number* is a convenient way to express the power output of a strobe. Think "GAD" (guide number equals aperture times distance). For example, if a strobe exposure is f8 at three feet, the GN is 24 (24 = 8 x 3).

A GN can be used to determine aperture for a given strobe-to-subject distance or vice versa. The two following examples assume a GN of 24:

- To determine aperture: If the strobe-to-subject distance is three feet, divide the GN by three to determine the aperture of f8 (24/3 = f8).
- To determine strobe-to-subject distance: If you wish to expose at f8, divide the GN by f8 to determine the strobe-to-subject distance of three feet (24/8 = 3)

GUIDE NUMBERS IN METERS

Some owner manuals provide detailed guide number charts based on meters. To convert a GN for meters to a GN for feet, multiply the GN for meters by 3.3.

CONVERTING A TOPSIDE
GN TO AN UNDERWATER GN

The power outputs of many strobes are rated in topside guide numbers for feet in air. To convert a topside GN to an underwater GN for apparent feet underwater, try dividing the topside GN

by a conversion factor of two for light skin. For example, a topside GN of 100 becomes an underwater GN of 50 (100/2 = 50).

●●● —————————————————————————————

The conversion factor of two for light skin is only a guideline. Because different strobes have flashtubes, reflectors and ports of different shapes, experiment to determine the actual conversion factor for your strobe and choice of subjects. ●●●

ESTIMATED UNDERWATER GN CHART FOR NIKON STROBES

ESTIMATED UNDERWATER GUIDE NUMBER CHART FOR NIKON STROBES						
	SB-102 & SB-104*			**SB-103****		
ISO	**M Full**	**M 1/4**	**M 1/16**	**M Full**	**M 1/4**	**M 1/16**
800	99 (70)	50 (35)	24 (18)	62 (44)	31 (22)	15 (11)
400	70 (50)	35 (24)	18 (12)	44 (31)	22 (15)	11 (8)
200	50 (35)	24 (18)	12 (9)	31 (22)	15 (11)	8 (6)
100	35 (24)	18 (12)	9 (6)	22 (15)	11 (8)	6 (4)
50	24 (18)	12 (9)	6 (4)	15 (11)	8 (6)	4 (3)
25	18 (12)	9 (6)	4 (3)	11 (8)	6 (4)	3 (2)
	Brackets=SB-102 & diffuser.*			*Brackets=SB-103 & diffuser.*		

Reading the above chart is simple. The instructions are as follows:

- **SB-102 and SB-103 without diffuser.** Find ISO film speed at far left column. Read across to find underwater

GN for each power setting. These guide numbers are at the left of each column, without brackets.

- **SB-102 and SB-103 with diffuser.** Use the guide numbers in brackets.
- **SB-104.** Use the SB-102 underwater GN (without diffuser).

• • •
—————————————————————————

My guide numbers, above, are lower than those specified by Nikon. This is because my guide numbers are based on angled strobe lighting, or lighting with longer strobe arms that provide greater separation between camera and strobe than do Nikon arms. You may wish to adjust the guide number values for your specific equipment and strobe-aiming techniques after trial-and-error testing.

—————————————————————————
• • •

EXAMPLE:
FINDING AN SB-103 UNDERWATER GN

Assume that you wish to use ISO 100 film and a SB-103 strobe with diffuser. You wish to find the underwater GN for a full-power flash.

1. Find ISO 100 at the left side of the underwater GN chart.
2. Read across to M full (manual, full power) column for the SB-103.
3. The underwater GN (in brackets) is 15.

THE SECRET EXPOSURE CHART

The Secret Exposure Chart is the result of years of trial-and-error testing and hours of mathematical computations. This table allows you to estimate strobe exposures for virtually any strobe available with accuracy of plus or minus one f-stop. Although strobe manufacturers often provide exposure tables, this is the exposure table that I use. (Guide number theory breaks down at close distances. Therefore, when strobe distance is

reduced from two feet to one foot in The Secret Exposure Chart, the change in aperture is one and one-half f-stops.)

THE SECRET EXPOSURE CHART					
	Underwater Guide Number				
	10-13	15-19	21-27	30-38	43-54
Ext. Tube	Strobe Distances (for measured inches)				
2:1 (f16)	--	3-6	4-8	6-12	--
1:1 (f22)	2-4	3-6	4-8	6-12	--
1:2 (f22)	3-6	4-8	6-12	8-12	--
1:3 (f22)	4-7	5-9	7-13	10-20	--
Strobe Dist.	Close-Up Apertures (for measured inches)				
8 in.	f11-16	f16-22	f22-32	--	--
12 in.	f11	f16	f22	f32	--
16 in.	f8-11	f11-16	f16-22	f22-32	--
Strobe Dist.	Apertures (for apparent feet)				
1 ft.	f8-11	f11-16	f16-22	f22-32	--
1.5 ft.	f8	f11	f16	f22	--
2 ft.	f5.6	f8	f11	f16	f22
3 ft.	f4	f5.6	f8	f11	f16
4 ft.	f2.8	f4	f5.6	f8	f11
6 ft.	f2	f2.8	f4	f5.6	f8

Reading the Secret Exposure Chart:

1. Find your underwater GN from the previous chart or by trial-and-error testing.
2. Find your underwater GN at the top of the chart.
3. You can use any exposure data shown in the column below the underwater GN.
4. If your underwater GN falls between columns, interpolate. For example, a guide number of 20 falls between the 15-19 and 21-27 columns. At three apparent feet you would use f5.6-8.

How to find your underwater GN for the Secret Exposure Chart (let's assume you have a non-Nikon strobe and don't understand guide numbers):

1. Determine what f-stop you would use at three apparent feet with your combination of strobe and ISO film speed. Let's use f8 for this example.
2. Multiply f8 times 3 feet to find your underwater GN of 24.
3. Read across the top of the chart until you find the 21-27 column. You can use any exposure data in this column.

EXAMPLE 1:
EXTENSION TUBE EXPOSURE

Assume that you wish to use a 1:2 extension tube. Your strobe and ISO film speed combination is f8 at three feet. Thus, your underwater GN (underwater guide number) is 24 (f8 times three feet).

1. Your underwater GN of 24 falls in the 21-27 column.
2. Find "1:2" at the upper left of the chart.
3. Read across to the 21-27 column and find 6-12 inches.
4. At f22, your strobe-to-subject distance will be 6 inches for dark subjects, 12 inches for light subjects and 9 inches (the midpoint) for average subjects.

EXAMPLE 2:
EXTENSION TUBE EXPOSURE
BETWEEN COLUMNS

Suppose your strobe has an underwater GN of 20, between the 15-19 and 21-27 columns. You want to find the strobe-to-subject distance for a 1:2 extension tube.

1. Find the midpoint of the strobe-to-subject range in the 15-19 column. The range is 4 to 8 inches; the midpoint is 6 inches.
2. Find the midpoint of the strobe-to-subject range in the 21-27 column. The range is 6 to 12 inches; the midpoint is 9 inches.
3. At f22, your strobe-to-subject range will be 6 to 9 inches.

EXAMPLE 3:
CLOSE-UP LENS EXPOSURE

Assume that you wish to use a Nikonos Close-up Outfit. Your strobe and ISO film speed combination is f5.6 at three feet. Thus, your underwater GN is 17 (rounded, f5.6 x 3 feet = 16.8).

1. Your underwater GN falls in the 15-19 column.
2. Read down the column and find the close-up apertures section, in the middle of the chart. Find the apertures f16-22, f16 and f11-16.
3. At a measured strobe-to-subject distance of 8 inches (left side of chart), your estimated aperture is f16-22. At 12 inches the aperture is f16. At 16 inches, the aperture is f11-16.

EXAMPLE 4:
YOUR PERSONAL EXPOSURE TABLE

Let's assume that you wish to make a strobe exposure table for

a specific ISO film speed and apparent strobe-to-subject distances from 1.5 to 6 feet. Assume that your strobe and ISO film speed combination has an underwater GN of 17.

1. Find your underwater GN in the 15-19 column, at the top of the chart.
2. Read down the column until you find the apertures for apparent feet.
3. With a label maker, or a laundry marker and tape, you can attach the following strobe exposure table to the side of your strobe.

EXAMPLE: PERSONAL EXPOSURE TABLE	
Distance	**F-Stop**
1 ft.	f11-16
1.5 ft.	f11
2 ft.	f8
3 ft.	f5.6
4 ft.	f4
6 ft.	f2.8

MANUFACTURER'S EXPOSURE TABLES

Manufacturers often provide decals showing exposure tables, or may provide circular or sliding exposure scales. Some tables (such as those provided with the Nikon SB-103) are hard to read. Calculators, such as those on the SB-102 are hard to understand. I prefer a simple table of distances and f-stops, such as those provided for the SB-104 and some non-Nikon strobes.

• • • ────────────────────────────────

Most manufacturer's calculators and tables seem to give f-numbers that are too high. You most often use a reduced ISO to get an accurate f-stop. For example, reading the table or calculator for ISO 50 film when you are using ISO 100 film will increase the exposure by one f-stop.

──────────────────────────────── • • •

Trial and Error Tables

Because the light outputs of strobes can vary from unit to unit, you may wish to make a "trial and error" exposure table. To do so, take a series of bracketed exposures, at half-stop intervals, at various apparent strobe-to-subject distances. Inspect the results and make your own exposure table. For best results base your standard on one subject reflectance, such as bare skin. Then, you can modify the f-stops for subjects of different brightness.

Flashmetered Tables

Using a flashmeter is my favorite method for making a preliminary exposure table for an untried strobe. I do this topside in air. The procedure is easy:

1. Set the flashmeter for 1/500 second.
2. Set the ISO on the flashmeter for one-half the ISO of the film used. For example, use ISO 50 for ISO 100 film.
3. Indoors, hold the flashmeter four measured feet from the strobe.
4. Aim the strobe directly at the meter and flash the strobe.
5. Read the f-stop indicated on the flashmeter.
6. The indicated f-stop is the estimated underwater f-stop for three apparent feet.

Setting the flashmeter for 1/500 second reduces the effect of room light. Reducing the ISO by one-half accounts for the absorption of light as it passes through water. The one-half correction is for light skin tones. Once you estimate the f-stop for

To estimate the proper manual flash exposure for a Nikonos close-up outfit, mount the strobe in the desired position, place the flashmeter in the framer and flash the strobe.

The flashmeter measures the amount of light striking its sensor. The reading is f16-22 for ISO 100 film. I set the meter for ISO 32 (a one-third-stop correction) for grayish subjects.

three feet, you can either flashmeter or estimate f-stops for other distances.

LIMITATIONS OF EXPOSURE TABLES

The strobe exposure table is based on a subject of predetermined reflectance, such as light skin or average gray. If you select subjects with more or less brightness or reflectance, you must use higher or lower-numbered f-stops than shown on the table.

Strobe tables are reasonably accurate up to about 20 percent of clear visibility (the distance at which you can see fine details). At longer distances, the suspended particles in the water upset our estimates. Dark particles block strobe light and light particles can reflect light from particle to particle. Strobe lighting becomes guesswork, so bracket your exposures.

ARMS AND BRACKETS

Let's start with the three requirements for a good strobe arm and bracketing system: ease of use, adaptability and simplicity. The simplest system that meets your needs is the best system. The best arms and brackets may not be those supplied by the strobe manufacturer. Ask these questions when selecting an arm and bracket system:

- How easy (or difficult) will it be to detach the strobe arm from the bracket?
- Can a second strobe be added later?
- If you use a separate exposure meter (such as the Sekonic Marine Meter), can you easily attach the meter mount to the bracket?
- Is the arm system useful for both wide-angle and close-up photography? Will parts of the arm get in the way when you use extension tubes?
- How bulky and heavy is the arm and bracket system?
- Can metal-to-metal fittings be completely flushed with fresh water during clean-up?
- Is the system cluttered with extra parts and pieces that only cause confusion?

··· 6 ···

Understanding TTL Strobe Exposures

For close-up underwater photography, TTL can be a fantastic tool for controlling exposures. At long distances in bright sunlight, TTL is less effective.

How TTL Works

TTL (through-the-lens) is a strobe exposure system based on the duration of the flash of light from the strobe. The TTL system measures the amount of strobe light that passes through the camera lens. When enough light reaches the film for the exposure, the TTL system turns the strobe off. It doesn't matter if you are using a Nikonos V, housed camera or the Nikonos RS. Nor does it matter which TTL strobe you are using; all TTL systems work the same way. (Note: Some writers may refer to TTL as "OTF" (off the film) because the system measures strobe light reflecting off the film.)

• • •
TTL works by varying the duration of the flash to control the amount of strobe light reaching the film. The TTL strobe exposure control does not measure or control the sunlight exposure.
• • •

When Should You Use TTL

TTL isn't some electronic marvel that will make all your exposures turn out perfect. TTL is just another photographic tool that you must learn how to use.

A TTL strobe will have a TTL power setting. For this Nikon SB-103 power switch, the FULL, 1/4 and 1/16 settings are for manual (non-TTL) exposure control.

TTL works best for close-up photography:

- When a subject of average reflectance fills the center one-third of the picture.
- When the strobe (rather than sunlight) determines the exposure.

TTL doesn't work in these situations:

- A small subject is off-center, and the TTL reads the distant background.
- At long distances in bright sunlight, when the subject is beyond the TTL automatic range.

CENTER-WEIGHTED SENSING AREA

The TTL sensor reads from the center one-third of the picture area. Thus, the subject must be centered in the picture if the TTL is to meter accurately. If the sensing area only sees the distant background, it doesn't shut the strobe off.

TTL works best with near subjects that fill the central picture area, and this sponge on the Sankisan Maru *filled the bill.*

Manual exposure is best for this trumpet-fish portrait. Because the TTL would respond to the back-ground, the fish would be overexposed.

TTL Auto Range

TTL controls light output by varying the duration of the flash. *TTL can reduce the output of a strobe, but can't generate more light than a full-power flash.* If the sunlight exposure is brighter than a full-power strobe exposure, TTL is meaningless. The subject is beyond the TTL auto range of the strobe and you will have a sunlight exposure with strobe fill.

Maximum TTL auto range is the distance on the strobe exposure table that corresponds to the f-stop selected. For example, look at the following exposure table:

STROBE EXPOSURES FOR APPARENT UNDERWATER FEET	
2 ft.	f11
3 ft.	f8
4 ft.	f5.6
6 ft.	f4

If the aperture selected is f5.6, for example, the maximum TTL auto range is four apparent feet. If the subject is four feet or further away, the strobe gives a full-power flash. Because TTL works by reducing the strobe output, TTL is meaningless beyond the automatic range.

● ● ● ————————————————————————————
To determine the TTL auto range for any distance or f-stop, simply look at the distance and full-power f-stop on the manual strobe exposure table you make for your strobe.
———————————————————————————— ● ● ●

Minimum TTL auto range. At strobe distances of about a foot or less, with fast films, the TTL may not be able to shut the strobe off quickly enough to avoid overexposure. However, with

ISO 50 and 100 films, used with extension tubes and close-focusing lenses, TTL strobe-to-subject distances of less than one foot are frequently used.

TTL f-stops. In my experience, the minimum TTL f-stop should be no more than one stop lower than the f-stop shown on the strobe exposure table for manual exposure control. When shooting close-ups, for example, if the manual exposure control f-stop were f22, the TTL f-stop should be no wider than f16. At f11, the TTL will tend to overexpose.

FULL POWER FLASH SIGNAL

Look at the ready light (either in the viewfinder or on the strobe) after you flash the strobe in the TTL mode. The ready light will either blink or glow after the strobe recycles.

Blinking ready light. The strobe has delivered a full-power flash. The strobe was at the edge or beyond the automatic range. If the strobe is determining the exposure, the picture may be underexposed.

Non-blinking ready light. The TTL has shortened the flash duration. The strobe is within the TTL automatic range.

TTL AND BRIGHT SUNLIGHT

Whenever sunlight overpowers strobe and determines the exposure, you must use the sunlight aperture. The strobe only provides fill lighting, even if it is set for TTL.

● ● ●

With the Nikonos V, the built-in exposure meters for sunlight and TTL are two completely different systems. They aren't electronically connected and don't communicate with each other. ***With the Nikonos RS***, *the sunlight and TTL systems communicate and work together in the A (auto) mode for matrix flash fill.*

● ● ●

I chose TTL for this barracuda portrait. Notice how the TTL reduces his bright silvery scales to an average gray.

TTL at Close Distances

TTL is great for close-ups and macro work because (day or night) the TTL strobe provides virtually all of the light for the exposure. You can set the aperture for close-ups, usually f16 or f22, and the TTL will control the exposure by varying the flash duration.

Testing the TTL

If the camera battery voltage drops, the connector contacts are dirty, or if the electronics fail, the TTL won't work. The TTL can trigger the shutter at 1/1000 second, which is too fast for synchronization with the strobe and causes underexposure. Or it may cause long shutter speeds that cause overexposure. Therefore, it's wise to test the TTL before use. Note: After closing the camera back you must advance the film to the first frame; this turns the camera's electronics on.

Part One of the TTL test:

1. The camera can be loaded or empty.

2. Advance the film counter to frame one.
3. Set the shutter for A.
4. Open the aperture to the lowest-numbered f-stop.
5. Set the strobe for TTL.
6. Aim the strobe into the camera lens.
7. Trigger the shutter.

If the TTL is working, the flash of light should be brief, and the recycle light should turn on quickly after the flash. If the flash is bright, and the ready light blinks for a full flash signal, the TTL didn't function.

Part Two of the TTL test:

1. Close the aperture to f22.
2. Aim the strobe away from the camera.
3. Cover the lens with your hand or lens cap.
4. Trigger the shutter.

If the TTL is working, the flash should be bright and the ready light should blink. Also, listen to the shutter. If you hear two sounds—clunk, clunk—the camera battery is too weak to maintain the shutter speed.

If the TTL system fails the TTL test, set the Nikonos V shutter speed for M90. This shuts off the electronics and locks the shutter at 1/90 second. Set the strobe for a manual power setting.

You may be able to correct the non-functioning TTL by changing the camera battery, cleaning the battery compartment, cleaning the flash socket contacts of both camera and strobe, or cleaning the sync cord contacts (See Part 6: Maintaining Your Equipment).

● ● ● ─────────────────────────────

Always test the TTL before every TTL photo dive. You can also test the TTL underwater. If in doubt, switch to manual exposure control. One or more totally black pictures on a TTL close-up roll could mean that the TTL is starting to fail.

───────────────────────────── ● ● ●

··· 7 ···

How To
Aim The Strobe

You are hand-holding your strobe and aiming by hand-eye coordination. Your computer brain triangulates the strobe angle and your line of sight so both converge on your subject. However, you missed. Your subject isn't there. Your subject's actual position is one-third further away than it appears to your eye. If you're confused, review apparent distances in Chapter 2.

The Major Error:
Aiming at the Apparent Image

The basic strobe position is at the upper left of the camera. The strobe is aimed at the subject, at an angle down from your upper left. (This is how strobe arms and brackets are designed.) If you aim the strobe at the subject's apparent image (the subject's position as your eye sees it), the center of the beam of light will pass between the camera and the subject. The result will be an underexposed subject and illuminated particles (backscatter) in the foreground.

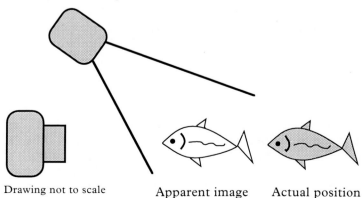

Drawing not to scale Apparent image Actual position

The apparent image aiming error increases dramatically when you are hand-holding your strobe at an angle to the subject and aiming by hand-eye coordination. (Drawing not to scale.)

FLASH POSITIONING INDEX

Some strobes (such as the SB-102, 103 and 104) have flash positioning index marks at the knuckle where the strobe head attaches to the arm. If you decide to keep the strobe on an adjustable arm that is attached to the camera, you must adjust the strobe angle so it intersects at the subject's actual position. The SB-104, for example, has index marks for 0.5 meters, 1 meter and infinity. I personally aim the strobe by eye, so it intersects behind the subject's image that I see. This way, the strobe is aimed at the subject's actual position.

MEASURING STICKS AND CORDS

Some photographers use measuring sticks or cords to measure underwater distances. If you wish to use knots or marks to show apparent feet, use 16 measured inches to represent each apparent foot.

● ● ● ───────────────────────────────
To convert measured distances to apparent distances, multiply measured distances by 0.75. For example, 16 measured inches equals 12 apparent inches (16 x 0.75 = 12). To convert apparent distances to measured distances, multiply apparent distances by 1.33. For example, 12 apparent inches equals 16 measured inches (12 x 1.33 = 16).
─────────────────────────────── ● ● ●

SITUATION
AIMING AT THE ACTUAL POSITION

Aim your strobe at a point no less than one-third behind the

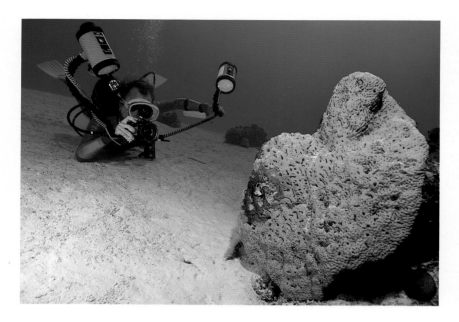

Mike Mesgleski is aiming his twin strobes at the subject's apparent image. Hey Mike, remember that the subject's actual position is one-third farther away than it appears to your eye!

subject's image that you see. The biggest problem will be when you are looking at your subject and aiming a handheld strobe by "feel" (hand-eye coordination). Your brain instantly directs your hand to aim the strobe at the image you see. You must constantly override the "feel" of the strobe arm in your hand and aim one-third behind what you see.

●●●

You can use an aiming light attached to the strobe for accurate aiming, but you may not be able to see the beam of the aiming light in bright sunlight.

●●●

SUSPENDED PARTICLES CAUSE BACKSCATTER

Water contains suspended particles which can block and

reflect light. If the strobe is held near the camera, light reflecting from the particles will be directed toward the camera lens. This causes backscatter—tiny bright spots that appear in your pictures.

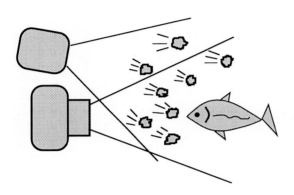

Suspended particles reflect light back to the light source. If the strobe (the light source) is near the camera, the light reflecting from suspended particles reflects toward the camera and causes bright spots to appear in your pictures.

Turbid water has a great number of suspended particles. Thus it is important to use strobe-aiming techniques that minimize backscatter from suspended particles.

SITUATION
TURBID WATER, SINGLE STROBE

While we would all enjoy taking pictures in gin-clear water, turbid water and backscatter are problems we often encounter. The three steps I use to minimize backscatter are:

1. Hold the strobe by hand forward of and above the camera.
2. Aim the strobe at an angle so the reflected light from suspended particles doesn't reflect toward the camera lens.
3. Aim the strobe so the edge of the beam angle just cuts in front of the subject. This minimizes the number of illuminated particles between camera and subject.

*Mike Haber actually aimed his wide-beam strobe over the top of "Sweetlips"
to avoid backscatter from suspended particles, and to accent her dorsal area
with soft strobe fill.*

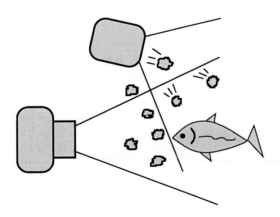

By aiming the strobe from any side (side, top or bottom), the light reflected from suspended particles is directed away from the camera lens. By angling the strobe so its beam just cuts in front of the subject, the number of illuminated particles between camera and subject is minimized.

• • •

*Aiming the strobe from above and in front of the the camera
(rather than from the upper left) not only spreads the light more
evenly over the picture area, but avoids backscatter in the upper-
left corner of the picture as well.*

• • •

SITUATION
Turbid Water, Two Strobes

Many photographers use two wide-beam strobes, on adjustable arms, especially for wide-angle photography. To minimize the number of illuminated particles in front of the camera lens, try aiming the strobes straight ahead.

1. Adjust the strobe arms so the two strobes are as far left and right as possible.
2. Aim the strobes straight ahead. The beams should overlap the center of the subject at about three feet.
3. For longer shots in turbid water, aim the strobes slightly outward from the straight-on position.

This overhead lamp, hanging in the engine room of the Shinkoku Maru, *required extreme side lighting (from top and bottom) with two strobes. One strobe was aimed downward to illuminate the top of the light shade; the other was aimed upward to illuminate the underside.*

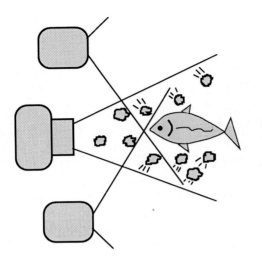

With wide-beam strobes, aiming the strobes straight ahead is often your best turbid water technique. The idea is to have the beam (or beams) cut in front of the subject. With wide-beam strobes, each lights one half of the picture area.

SITUATION
TURBID WATER,
EXTREME SIDE LIGHTING, TWO STROBES

This situation usually takes one or two assistants, depending on how far the strobes will be from the camera.

1. Aim the strobes at the subject from two opposite sides—left and right or top and bottom.
2. If using strobes with extremely wide beams, angle them so the beams intersect behind the subject.

● ● ●
A third strobe, in the slave mode, can be placed behind the subject to outline it against the background with rim lighting. Aim the strobe toward the camera, but keep it out of sight of the camera lens or it will flare in your picture.
● ● ●

Three strobes were used to illuminate the binnacle of the **Nippo Maru**, *two for side lighting and one for backlighting. I aimed my hand-held strobe from the left; Mike Mesgleski held my second strobe at the right. A Nikon SB-102 strobe, set for slave and 1/4 power was hidden behind the binnacle.*

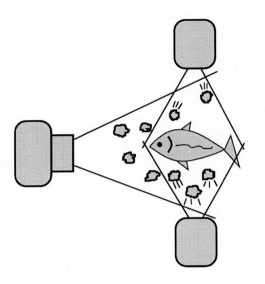

With extreme side lighting, the light reflecting from suspended particles is directed away from the camera lens at angles up to 90 degrees or more.

SITUATION
Turbid Water, Back Lighting

If you can position a strobe behind a subject, the strobe light will help outline and define a subject that is against a dark background. The effect of the suspended particles in the water will be minimized, and some translucent subjects will tend to glow. To avoid flare, don't let strobe light strike the camera lens directly.

PART
... 4 ...

HOW TO
USE THE
NIKONOS V

··· 8 ···

MAKING FRIENDS WITH THE NIKONOS V CAMERA BODY

This is a "get acquainted with your camera" chapter. We won't be actually using the controls or taking pictures. We just want to see where the controls are, and what they do. Get your camera body so you can look at the controls as you read.

SETTING THE ISO FILM SPEED

Your film will usually have a number as part of its name. Let's assume that you are using Ektachrome 100, for example, the "100" is the film speed we discussed in Chapter 2. We set the ISO dial on the camera body for 100. This tells the camera's metering system how much light Ektachrome 100 needs for an exposure.

• • •
Setting the ISO film speed is easy. Simply lift up on the ISO film speed dial and rotate it until the 100 on the dial aligns with the index mark on the camera body.
• • •

SETTING THE SHUTTER SPEED

Setting the shutter speed is also easy: Rotate the dial until the desired shutter speed aligns with the index mark on the camera body. I generally use 1/60 second unless there is a specific reason to use other speeds.

FILM ADVANCE LEVER

Use your thumb to move the film advance lever to your right (the shaft rotates counter-clockwise). You can use one single stroke, or several short strokes. Don't force the film advance lever at the end of the stroke. Forcing the lever could damage the camera.

SHUTTER RELEASE AND LOCK

Depress the shutter release button with your right, first finger to take a picture. Don't punch the button! Depress it with a gentle squeezing motion. *When the shutter triggers, it should be a surprise.* Otherwise, you may be punching the button.

The shutter release lock is supposed to keep you from accidentally depressing the shutter release button. However, it may prevent you from taking the picture of a lifetime if you forget that it is engaged. Therefore, I don't use the shutter release lock. Yes, the shutter can be triggered accidentally, but you shouldn't have your finger on the release button if you don't intend to take a picture.

Looking down at the Nikonos V camera body, we see the ISO film speed dial and rewind crank on the left. The shutter speed dial, film advance lever, shutter release button, film frame counter and shutter release lock are on the right.

Viewfinder Markings

Look inside your Nikonos V viewfinder; you will see some parallax marks. These show picture areas for infinity and 2.75 feet for the 35mm lens. Great idea, but lousy implementation. The marks show only 85 percent of the true picture area. Everything you see in the viewfinder will be in the picture! Also, when you tilt the camera upward toward bright areas, the marks may disappear. Personally, I ignore these markings.

Viewfinder Displays

After closing the camera back, use the film advance lever and shutter release to advance the film counter to frame number one. (You don't need to put film in the camera to do this.)

Set the shutter speed for 1/60 second. Look into the viewfinder and depress the shutter release button halfway. You should see a glowing 60 at the bottom of the viewfinder. If you don't see the 60 immediately, try shifting your eye up and down. You can't see the 60 if your eye isn't aligned properly. Seeing the 60 tells you (for now) that the metering system is activated. The system turns off after about 16 seconds and the 60 disappears. To get the 60 back, press the button halfway down again.

● ● ● ─────────────────────────────────────

If you can't see a glowing 60, move your eye up and down, relative to the viewfinder. If your eye isn't aligned to the viewfinder, you may not see the glowing 60. If the 60 still doesn't glow, clean or replace the battery as discussed in Chapter 23.

───────────────────────────────────── ● ● ●

Loading Film

If you have a junk roll of outdated film, use it for film loading practice. The method I will show you is different than that shown in the Nikonos owner's manual. My way is faster, and is safer if you must load in wet conditions.

● ● ● ─────────────────────────────

The following list of film-loading steps may seem overwhelming at first glance. However, if you will take the time to follow each step as you practice loading your camera, you will significantly speed up your film changing time.

───────────────────────────── ● ● ●

Being left-handed is an advantage (lucky me) because the film is loaded from the left. The basic steps are:

1. If the camera has just been in the water, wipe it dry.
2. Set the shutter speed dial to R (the rewind position).
3. Rewind if there is exposed film in the camera. Leave the rewind crank in the up position.
4. If the camera is damp, tilt the camera so the lens faces upward. This keeps stray water droplets from dripping into the camera body.
5. Use your left hand to open the latch; use your right thumb to keep the camera back from snapping open suddenly. This keeps water droplets from being sucked into the camera body.
6. Open the back slowly, and let the film cassette drop out into your left hand.
7. Rest the camera body face down and gently wipe water droplets off sealing surface. Some droplets will be on the O-ring and sealing surfaces. This is normal.
8. Raise the film advance lever. Raise the pressure plate and tuck it under the advance lever. If the lever won't raise high enough, set for the closest shutter speed, trigger the shutter, return the dial to R and try again.
9. Insert the film cassette in place. Angle it down at 45 degrees to the top of the camera, with the film opening at the top. The cassette should drop in place easily.
10. With the thumb and first two fingers of the left hand, squeeze the sides of the film leader to stiffen it.
11. Push the end of the leader into one of the slots of the take-up spool.
12. While holding the leader in place, rotate the take-up spool to the left with the first finger of your right hand.

Before loading film, gently tuck the film pressure plate under the film advance lever. You may have to trigger the shutter once to free the film advance lever.

13. Lower the pressure plate and tap it in place with a fingertip.
14. Hold the bottom of the take-up spool with a finger as you take up the slack in the film with the rewind crank.
15. Close the camera back and lock the latch.
16. Set the film speed dial for a shutter speed (usually 1/60 second).
17. Advance the film three times (advance, fire, advance, fire and advance.) The rewind crank should rotate with each advance to indicate that the film is advancing.
18. Look into the viewfinder and depress the shutter release button halfway. You should see a glowing 60 in the viewfinder. This means the automatic functions of the camera are turned on.
19. Rotate the rewind crank in the opposite direction of the arrow as you apply slight downward pressure. This lowers the rewind crank; you can do this with one finger.

Here's how to stiffen the end of the film leader so you can shove it into the take-up spool slot. Hold the film by the edges with your thumb and second finger, and then press the center of the film with your first finger.

Is the Film Advancing

Shooting 36 exposures, without the film advancing, is a lousy way to conserve film. Make sure you do step 17 (above). Watch the rewind crank turn as you advance to frame number one.

Is the Film Rewound

Opening the camera before rewinding the film is a typical mistake that will ruin several frames of film! Therefore, set the shutter speed for any speed other than R. Raise the rewind crank and gently try to rewind the film. If you feel resistance, there is film in the camera. If there is no resistance, the film has been rewound or the camera is empty.

● ● ●

If you accidentally open the camera back before the film is completely rewound, close it immediately and you will only lose a few shots. The longer the back is open, the greater the chance of additional frames being ruined.

● ● ●

Is the Camera Flooded

A flooded camera can ruin your day, and possibly your Nikonos V. The telltale signs of a flood are as follows:

- The film won't advance smoothly (because the film emulsion is swollen with moisture).
- The flash won't fire, or it self fires (because the flash contacts are damp).
- You see water droplets or fogging in the viewfinder, lens port or frame counter window.

If you suspect flooding, turn off the electronics by setting the shutter speed dial to M. If using a strobe, turn it off also. Then get the camera topside as soon as possible. Hold the camera lens down and don't swing it about. Swinging the camera around splashes water everywhere. Note: See Chapters 25-27 for maintenance tips.

NIKONOS V 35MM AND 28MM NIKKOR LENSES

The 35mm lens is the standard equipment lens for the Nikonos V camera. Underwater, it covers an angle of view comparable to that of your eye. The 28mm lens covers a slightly wider angle of view.

LENS COMPATIBILITY

The Nikkor 35mm and 28mm lenses can be used with any model Nikonos camera body from the Calypso and Nikonos I to the Nikonos V. These lenses cannot be used with the Nikonos V. R S

LENS COMPARISON CHART			
Nikkor Lens	**Aperature Range**	**Minimum Focus**	**Picture Angle★**
35mm	f2.5-f22	2.75 ft.	46 Degrees
28mm	f3.5-f22	2 ft.	59 Degrees

★The underwater picture angle is the angle of view the camera sees. The measurement is diagonal, across opposite corners.

W NIKKOR 35MM F2.5 LENS

The 35mm lens is the standard equipment lens for the Nikonos V camera. The "W" designation means it can be used both topside and underwater. When set for the minimum focus

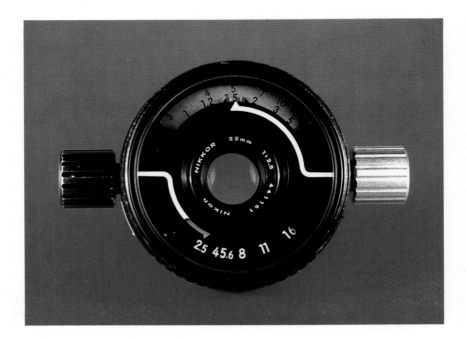

The 35mm lens has aperture and focus control knobs, aperture and focus scales, and a depth of field indicator. As you can see, at f5.6 and a focus setting of 5, depth of field is minimal.

of 2.75 apparent feet, it covers a picture area slightly less than two by three feet. This distance and picture area are best used for head-and-shoulder diver portraits and fish photography. The 35mm lens is often used with the Nikon close-up outfit and extension tubes to photograph tiny subjects.

The 35mm lens has click stops for each of the f-stops shown on the aperture scale. These click stops only indicate that the lens is set for one of the f-stops marked on the aperture scale. You can set the aperture between the click stops.

● ● ● ─────────────────────────────

When aiming the 35mm lens with the built-in viewfinder, remember that the markings you see in the Nikonos V viewfinder show only 85 percent of the actual picture area. Ignore the markings and use the entire area shown in the viewfinder to aim your 35mm lens.

───────────────────────────── ● ● ●

THE 35MM ERROR

The most frequent error beginners make with a 35mm lens is trying to take wide-angle pictures that should be taken with a 20mm or 15mm lens. They must back off so far that image and color quality is degraded by suspended particles and absorption of color. They try to shoot subjects that are too big and too far away.

● ● ●

Silhouettes, shot from below against the bright surface, are about the only long-distance 35mm shots that will have pleasing sharpness and contrast. For other wide-angle views, use a wide-angle lens that matches your subjects.

● ● ●

High-contrast upward silhouettes are the only wide-angle shots you can take effectively with a 35mm lens. Why? Because you need definite shapes and strong contrast. The 35mm and 28mm lenses are sometimes best for large subjects that you often can't (or don't wish to) get close to, such as hammerhead sharks. In these cases, try to get lower than your subject to increase contrast.

UW NIKKOR 28MM F3.5 LENS

The 28mm lens is optically corrected for underwater use, thus it is a sharper lens from corner to corner than a 35mm lens. The front port isn't just a glass window (as with the 35mm lens). It is concave on both sides to increase sharpness in the corners of the picture. Although similar in design to the 35mm lens, the 28mm lens doesn't have click stops on the aperture (as do all other Nikkor lenses for both the Nikonos V and Nikonos RS).

Because the 28mm lens focuses down to two feet, it's great for portraits of friendly angels, large eels and other such approachable critters. It's often the best lens choice for seals, sharks and other larger sea life (sometimes even whales) that you can't get close to. With a 20mm or 15mm lens, these larger creatures can appear too small in your pictures if you can't get close. The Nikonos close-up outfit and extension tubes can also be used with the 28mm lens for close-ups of smaller critters.

● ● ● ──────────────────────────────────

If you use the built-in camera viewfinder with a 28mm lens, the picture area photographed will be larger than the entire view you see in the viewfinder.

────────────────────────────────── ● ● ●

As for disadvantages, you still have the "too big and too far" mistake previously discussed in the 35mm lens section. Also, the 28mm lens produces topside pictures with blurry corners because the port is corrected for underwater use.

ACCESSORY VIEWFINDERS

Accessory viewfinders attach to the accessory mount on top of the camera body. These finders give you a larger view of the picture area than you see in the built-in viewfinder of the camera body. Accessory viewfinders are especially useful for the 28mm lens, because the camera viewfinder doesn't show the entire 28mm picture area.

Some accessory viewfinders are too bulky and are mounted too high above the camera body. Several viewfinders have a parallax adjustment with a hard-to-read distance adjustment. You are supposed to adjust the tilt of the viewfinder to match the distance to your subject. You will find this is quite difficult to do (or remember to do) when photographing moving subjects.

Some viewfinders have large dark lines to show picture areas for different lenses. I find these lines distracting.

● ● ● ─────────────────────────────

For me, the perfect viewfinder would be tilted for parallax correction at three apparent feet, show 100 percent of the picture area at that distance, show a large image size and would not have markings for parallax or picture area. Three viewfinders I like are the old-style Nikonos 15mm viewfinder (with the yoke that fit under the camera body), the Nikons 20mm viewfinder and the unmarked Sea & Sea viewfinder for their 15mm lens.

───────────────────────────── ● ● ●

Don't Get Too Close

Users of 35mm and 28mm lenses often get too close to their subjects because they choose subjects that are too small for the lens. Don't move in to a foot or so and try to shoot a portrait of a tiny four-inch fish. If you can reach out and touch your subject, you are too close. If your subject is smaller than the back of your camera, it is too small (unless it is part of an overall scene).

Don't Get Too Far Away

At the other extreme, don't use a 35mm or 28mm lens to shoot scenic views of large subjects, such as shipwrecks. With the exception of upward silhouettes, you can't take sharp pictures at distances greater than about ten feet. The suspended particles in the water block the len's view of the subject, and colors are lost as light passes through the water. It's not the fault of the lens; you're just too far away.

ESTIMATING DISTANCE

Many of your shots with the 35mm and 28mm lenses (as well as with the 20 and 15mm lenses) will be shot at three apparent feet. Because depth of field is limited, you must estimate this distance carefully. You can use the *Church Salute*, as described in the following situations:

SITUATION
SHOOTING A DIVER PORTRAIT

The goal is to take a diver portrait at an apparent distance of three feet. Use the *Church Salute* to estimate distance:

1. Set focus for three feet.
2. Hold your camera in the picture-taking position.
3. You and your subject extend your arms and fingers toward each other and touch fingertips. The distance from the film plane of your camera to your buddy's nose will be approximately three apparent feet.
4. Lower your arms and take the picture.

Note: For two feet with the 28mm lens, touch each other's wrists (modified *Church Salute*). This will be approximately two apparent feet.

SITUATION
PHOTOGRAPHING MARINE LIFE

The goal is to estimate apparent distances. Because marine life can't reach out and touch fingertips with you, use these modified *Church Salutes*.

1. If you can just touch the subject, the distance is about one and one-half apparent feet. This is too close with either the 35mm or 28mm lenses.

Avoid the temptation to photograph large subjects with the 28mm lens. At distances beyond about three to five feet, too much sharpness and detail will be lost. The exception being upward silhouettes which depend on shapes and contrast.

Both the 35mm and 28mm lenses are good for the head-and-shoulder diver portraits. Use the Church Salute to estimate camera-to-subject distance.

2. If you can reach halfway, the distance is three apparent feet.
3. If the subject seems to be just beyond your fingertips, the distance is two apparent feet. This is minimum distance with the 28mm lens.

PRACTICE TOPSIDE WITH A YARD STICK

The goal is to train your eye to estimate three feet. Hold your camera in your right hand, and hold a yardstick in your left hand. Keeping the yardstick out of sight, aim the camera at an object that appears to be three feet away. Then raise the yardstick and measure the distance from the film plane to the object. After several attempts, you will be able to estimate three feet within one or two inches.

● ● ● ────────────────────────────────

Even though you use apparent distances underwater, you can use three measured feet when you practice topside with the yardstick. The idea is to train your eye to estimate three feet as your eye sees it.

──────────────────────────────── ● ● ●

SETTING THE APERTURE

With either the 35mm or 28mm lens, place the lens on the camera body with the aperture control (the black knob) on the left when you are shooting sunlight pictures. Preset for f22 and always turn the knob away from you to adjust aperture while metering. This way you always know which direction to turn the knob, you don't have to take your trigger finger from the shutter release and you will always see the viewfinder LED displays in the same sequence.

When using a strobe, it may be more convenient to place the aperture control knob on the right. This way you hold the strobe arm with the left hand and adjust aperture with the right. Start at f22, but turn the knob toward you to adjust aperture.

● ● ● ────────────────────────────────

No matter which method you use, standardize your procedures: By always starting at f22, you always rotate the aperture knob in the same direction and always see viewfinder displays in the same sequence.

──────────────────────────────── ● ● ●

USING DIFFUSERS

With the 35mm lens, you don't need to use a wide-angle diffuser with a Nikon SB-102 or SB-103. With the 28mm lens, the diffuser is optional. Either strobe will light the central picture area, but not all four corners.

··· *10* ···

NIKONOS V 20MM AND 15MM NIKKOR LENSES

Let's start with the bottom line: These wide-angle lenses allow you to get closer to your subjects. The closer you can get, the less water between lens and subject, and the sharper and more colorful your pictures will be. Both the 20mm and 15mm lenses are designated "UW" because they are for underwater use only.

LENS COMPATIBILITY

The Nikonos 20mm and 15mm lenses can be used with any model Nikonos camera body from the Calypso and Nikonos I to the Nikonos V. These lenses cannot be used with the Nikonos RS.

LENS COMPARISON CHART			
Nikkor Lens	**Aperature Range**	**Minimum Focus**	**Picture Angle★**
20mm	f2.8-f22	1.3 ft.	78 Degrees
15mm	f2.8-f22	1 ft.	94 Degrees

★The underwater picture angle is the angle of view the camera sees. The measurement is diagonal, across opposite corners.

WIDE-ANGLE SUBJECTS

Wide-angle lenses are necessary for photographing large sub-

jects, such as entire divers, groups of divers, scenics and sunken shipwrecks. The subjects are too large for the standard 35mm or even the 28mm lens. You would have to shoot from too far away, through too many suspended particles. The results would be blurry pictures. Even for closer subjects, such as diver portraits, a wide-angle lens minimizes camera-to-subject distance.

UW NIKKOR 20MM F2.8 LENS

Although the 20mm wide-angle Nikkor costs about half the price of the 15mm Nikkor, the 20mm lens optics are excellent. Given the same conditions of water clarity and camera-to-subject distance, both lenses produce (to my eye) equally sharp images.

Bearing the scars of years of hard use, my Nikonos 20mm and 15mm lenses still take extremely sharp pictures. I have marked the aperture and focus indexes of the 20mm lens, and the focus knob of the 15mm lens, with yellow tape to make the control settings easier to read in dim light.

The 20mm lens is excellent for portraits of divers or marine creatures. For beginners, the 20mm lens is often easier to use than the wider 15mm lens. They find the aperture and focusing scales are easier to read and use, and that the camera with lens isn't as heavy to hold. When shooting large subjects, such as divers, their subjects fill the picture area. When using the 15mm lens, beginners tend to have too much empty space between the subject's image and the edges of the picture.

The 20mm lens doesn't have a depth of field scale. Rather, three color-coded markings are printed on the lens mount—yellow for f4, orange for f5.6 and red for f11. Most users tend to ignore these marks as they are somewhat hard to read. Besides, depth of field is reasonably deep with the 20mm lens. At a focused distance of three feet, with an aperture of f5.6, for example, depth of field extends from approximately two to six feet.

The 20mm lens is great for diver portraits and pictures of divers interacting with large fish.

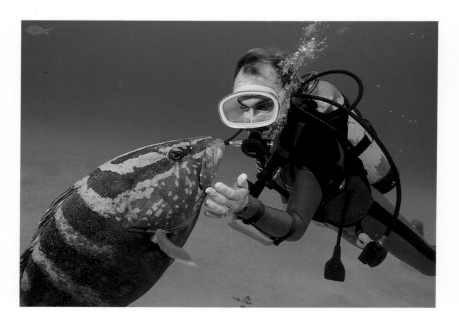

● ● ● ──

The aperture and focus scales, especially the focus scale, are difficult to read in dim light. Therefore, I use white tape to mark the distances on the focus scale and the index mark on the aperture scale.

── ● ● ●

THE 20MM VIEWFINDER

The 20mm viewfinder comes with a removable mask. This mask is for use with the 28mm lens; remove the mask when you are using a 20mm lens.

When you first look into your new 20mm viewfinder, in air, your heart may skip a beat—the image you see is blurry! But not to worry. The optics are designed for underwater use only.

You will see two parallax indicators jutting into the picture area of the viewfinder. These mark the top of the picture at the minimum focused distance of the lens, 1.3 feet.

Looking inside the 20mm viewfinder, the parallax indicators (the two "hooks" near the tops of the diagrams) show the top of the picture area at 1.3 feet. Because the viewfinder only shows 90 percent of the actual picture area, I've estimated the true picture area in the viewfinder diagram at right. Drawings not to scale.

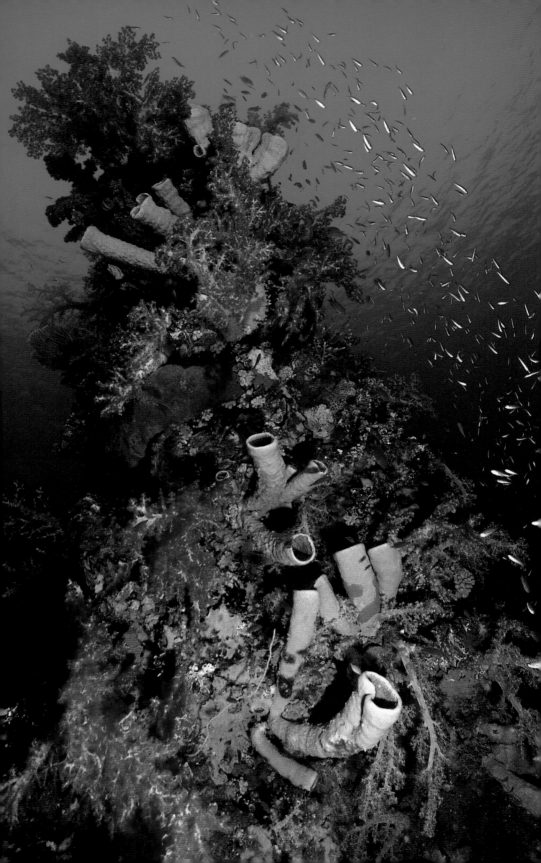

UW NIKKOR 15MM F2.8 LENS

The Nikkor 15mm lens is undisputed "King of the Hill" for many professional underwater photographers. It produces extremely sharp images. Because the dome port of the 15mm lens is part of Nikon's optical design, 15mm lens images are usually sharper than equivalent lenses of housed cameras. (This is because the dome ports of camera housings aren't always optically matched to the wide-angle lenses used.)

The 15mm lens allows you to photograph larger subjects than the 20mm lens, at closer distances. The 15mm lens also allows you focus as close as one foot for wide-angle close-ups. For professionals and serious amateurs, this makes the 15mm lens worth the price.

● ● ●

The aperture control knob may confuse beginners, at first, because it is located at your lower left, out of sight. You must locate and operate the knob by feel.

● ● ●

Because the focus scale is hard to read in dim light, I mark the focus control knob and index mark with white tape. As for the aperture control, I start at f22 and count click stops to determine aperture.

● ● ●

Beginners often find the 15mm lens harder to master than the 20mm lens. Because the picture area is so large, beginners (and even many experienced underwater photographers) often photograph subjects from too far away. If the scene looks OK to your naked eye, cut the distance in half before composing with the 15mm viewfinder.

● ● ●

My 15mm lens allowed me to get close enough to capture the colors and details of the undersea life adorning this lifeboat davit on the Fujikawa Maru.

The 15mm Viewfinder

As with the 20mm viewfinder, the 15mm viewfinder doesn't focus in air. Underwater, it shows large, bright images.

The various picture areas and parallax markings inside the 15mm viewfinder resemble a street map of Miami. To many, these marks are distracting and confusing. Markings indicate the picture areas for 0.3 meters, 0.6 meters and 1.5 meters. For simplicity, think: *one, two and far.* Let 0.3 meters equal one foot, 0.6 meters equal two feet, and let 1.5 meters equal distances further away.

The large rectangle is the picture area at 1.5 meters and beyond. The dashed line indicates the top of the picture at 0.6 meters. The four corner markings indicate the picture area at 0.3 meters. Drawing not to scale.

● ● ● ────────────────────────────

To further confuse viewfinding, the picture area markings only show 90 percent of the true picture area. I would prefer a viewfinder without the markings.

──────────────────────────── ● ● ●

Viewfinder Test

Both the 20mm and 15mm viewfinders require testing and practice. First of all, I always have my photo students do the following viewfinder test:

1. Photograph an underwater subject that just fills the

viewfinder (or viewfinder marking selected) from top to bottom.
2. Photograph an underwater subject that fills the viewfinder from side to side.
3. Repeat these test exposures at various distances.
4. After your film is processed, compare the images you see on film with your memories of the images you saw in the viewfinder.

You'll be amazed at the results! You'll see excess space above, beside and below your subjects that you didn't see in the viewfinder. If you use prescription lenses, the images on film may be off center. This is because the alignment of your eye to the viewfinder, as your line of sight passes through several layers of glass, may not be true.

WIDE-ANGLE VIEWFINDING TECHNIQUE

Accurate wide-angle viewfinding requires practice. For best results, follow these steps:

1. Compose while looking through the viewfinder.
2. Look at the entire picture area, from corner to corner.
3. Fill the viewfinder with subject, from edge to edge.
4. If close to subjects, allow for parallax.

The most common beginner's mistake is to compose wide-angle pictures by eye as they peek over the top of the viewfinder. Then, they raise the camera and use the viewfinder as a "gun sight" to aim the camera. The results are pictures taken from too far away.

● ● ● ────────────────────────────────

Ignoring details in the corners (heads, fins, etc.) is another major problem. Don't become so engrossed with what you see in the center of the viewfinder that you ignore distractions in the corners.

──────────────────────────────── ● ● ●

Remember, the viewfinder only shows 90 percent of what will be in the picture. Move in close and fill the viewfinder with the subject. Also, don't choose subjects that are too small for your lens. A three-inch fish photographed three feet away, for example, will be only a dot in a wide-angle picture.

Because the viewfinder is mounted above the lens, the line of sight is above the line of sight of the lens. This is called parallax. The respective lines of sight intersect at 1.5 meters, and parallax correction marks are shown in the viewfinders. If these marks confuse you, use some good old "Kentucky windage." Ignore the marks and aim at an imaginary spot about three inches above the center of your subject area.

SITUATION
Fast Action, Fast Aiming

The water pistol technique (point and shoot). The goal is to aim the camera when events happen too quickly for you to aim with the viewfinder. This may happen, for example, at Stingray City, Grand Cayman.

1. Preset the aperture, focus and strobe angle.
2. Hold the camera about one or two feet in front of your face.
3. Point camera at subject; look "through" the camera back.
4. Pan (move the camera) to following the moving subject.
5. Take the picture.

● ● ● ────────────────────────────────
Look at your subject in a straight line, with the camera back directly in your line of sight. If your head is higher than the camera, you will aim too high (at the subject's apparent position rather than its actual position).
──────────────────────────────── ● ● ●

Wide-Angle Depth of Field

Because depth of field increases with picture area (as well as

When using the "water pistol" technique, pretend that you are looking through the camera back.

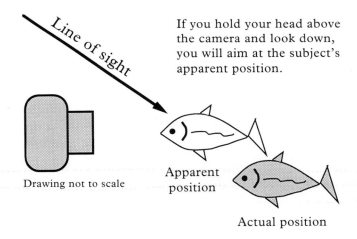

Line of sight

If you hold your head above the camera and look down, you will aim at the subject's apparent position.

Drawing not to scale

Apparent position

Actual position

with smaller apertures), both the 20mm and 15mm lenses provide excellent depth of field. However, to my eye, the depth of field is less than that shown on the depth of field indicators.

Using Diffusers

Use the wide-angle diffusers for the Nikon SB-102 and 103. Otherwise, neither strobe will cover the wide-angle picture area of a 20mm or a 15mm lens. If, however, you want a "spotlight" effect, remove the diffuser. The SB-104 doesn't have a wide-angle diffuser because it has a 100-degree underwater beam angle.

··· *11* ···

HOW TO TAKE NIKONOS V SUNLIGHT EXPOSURES

During my underwater photography courses, dozens of students have asked, "Why should I learn how to take sunlight pictures?" Let me give you some answers.

WHY TAKE SUNLIGHT PICTURES

Anytime you take underwater photographs in bright conditions, at distances further than about four or five feet, you are making sunlight exposures. The strobe only adds fill lighting. Therefore, you should learn to use your primary light source— sunlight! If you ignore sunlight and think only of strobe exposures, you are basing your exposures on the secondary light source.

• • •

I recommend mastering sunlight exposures first. Add strobe fill lighting later. This "one, two" approach will improve your lighting techniques dramatically.

• • •

THE NIKONOS V METERING PATTERN

The sunlight metering pattern of the Nikonos V is *lower center weighted*. This means that lower center of the picture area has the greatest influence on the exposure meter reading in both the A (auto) and M (manually set shutter speed) modes.

• • •

Important: While the sunlight metering pattern is lower-center weighted, the TTL metering system is center weighted. The sunlight and TTL metering systems are separate systems that operate independently of each other.

• • •

How to Use "A" (Auto)

A (auto) is an aperture priority mode. You set the aperture (select the f-stop), and the automatic exposure control selects the shutter speed. The basic steps are:

1. Set the film speed dial for the ISO film speed.
2. Set shutter speed for A, and advance to frame one.
3. Verify that you have a display (depress shutter release halfway and look in the viewfinder for any LED display).
4. To meter subject, depress shutter release halfway.
5. Starting at f22, open the aperture until you see the desired shutter speed displayed in viewfinder.
6. Adjust focus, compose and take picture.

By starting with f22 and adjusting by opening the aperture, you will always see the LED displays in the same order. At first, you may see only a blinking arrowhead in the lower right of the viewfinder. As you open the aperture, you will see the shutter speeds selected by the automatic control. These speeds will appear in the following order: 30, 60 125, 250, 500 and 1000.

• • •

If you see two numbers, 60 and 125, for example, the automatic control has selected a shutter speed somewhere between 1/60 and 1/125 second. It could 1/75, 1/115 or any other speed between 60 and 125.

• • •

Put it on "A" and Flail Away

This is a "point and shoot" technique. The key idea is to adjust

Typical Nikonos V LED shutter speed panel displays for A (auto). The shutter speed changes when you change the aperture	
◄	Flashing left-aiming arrow signals overexposed
500	A (auto) selected 1/500 second
125	A (auto) selected 1/125 second
125 60	A (auto) selected a shutter speed between 1/125 and 1/500 second
60	A (auto) selected 1/60 second
30	A (auto) selected 1/30 second
►	Flashing right-aiming arrow signals underexposure

the aperture until you see the desired "average" shutter speed for your subject. As you move the camera to follow moving subjects, the actual shutter speed will vary around the average shutter speed you've selected. In other words, set the shutter speed dial for A and flail away. What shutter speed should you select? Some basic choices are:

- Use 60 for stationary and slow-moving subjects.
- Use 125 for subjects moving at moderate speeds.
- Use 250 for fast-moving subjects.

SITUATION
FAST ACTION,
"A" (AUTO) EXPOSURE CONTROL

The goal is to take pictures when you don't have time for manual exposure settings. Imagine that you are at Stingray City, Grand Cayman. The depth is about 10 feet, and the rays are swooping all around you. *Put it on A and flail away.*

1. Set the film speed dial for the ISO film speed.
2. Set the shutter speed dial for A. (If the strobe is on, turn it off.)
3. Set the focus for three feet (for this example).
4. Aim the camera at a level angle.
5. Adjust the aperture for the 250 shutter speed display.
6. Aim and shoot as the rays swoop by.

● ● ● ───────────────────────────────────────

The level-angle shutter speed of 250 will change as you follow the action, probably varying from 500 to 125 as you aim up and down. That's fine—the average shutter speed of 250 will stop the action. Warning: In dim conditions, you may have to set the aperture for wide open and hope the shutter speed will be sufficient.

─────────────────────────────────────── ● ● ●

"Put it on A and flail away" is often the best way to photograph the rays of Stingray City. Using Ektachrome Underwater (ISO 50), I had trouble getting a fast enough shutter speed to stop the action. A higher-speed film would have produced a sharper image.

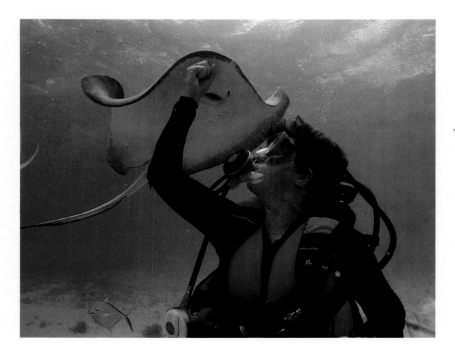

This Japanese tank, resting on the deck of the Nippo Maru, *was an excellent subject for A (auto) exposure control because of low-contrast sunlight. I "put it on A and flailed away."*

SITUATION
LOW CONTRAST,
"A" (AUTO) EXPOSURE CONTROL

The goal is to use the correct exposure in low contrast situations. Imagine that you are approaching a Japanese tank on the deck of a sunken vessel. The scene is bright enough for a sunlight exposure, and the contrast between dark and light subject areas is low. You're beyond the range of your strobe, so you decide to shoot sunlight exposures. *The procedure steps are the same as for fast action (above).*

• • •

Because the scene below you is low contrast, the Nikonos V automatic exposure control will be accurate. The shutter speed will vary around the average shutter speed. You put it on A and flail away.

• • •

SITUATION
High Contrast, Silhouettes,
"A" (Auto) Exposure Control

You look up at your subject, a diver swimming to the swimstep of the boat. Both the diver and boat are silhouetted against the overhead sun. However, the relative positions of the boat, sun and diver are constantly changing. You don't have time for manual exposure control. *The procedure steps are the same as for fast action (two headings above).*

• • •

Some of your pictures may be over- or underexposed, but most will be properly exposed. The dark and bright subject areas are constantly shifting, and the automatic exposure control will average the brightness it sees and select a shutter speed near the average speed you selected.

• • •

Because the relative positions of divers, boat and sun were constantly changing, manual exposure control would have been difficult. I "put it on A and flailed away."

Manual Exposure Control

With manual exposure control, you manually select a shutter speed and use the built-in exposure meter to find the correct f-stop. Manual control takes more time and effort than A (auto) exposure control. You must make an aperture adjustment each time the lighting condition or camera angle changes. (In the following sections, we will assume that your shutter speed is set for 1/60 second and that your strobe is turned off.)

- When you first look into the viewfinder, you will see two LED displays. A glowing, non-blinking 60 indicates that you have manually set the shutter speed for 1/60 second. A blinking arrowhead indicates that there isn't enough light for an exposure.

- As you slowly open the aperture, the blinking arrowhead disappears, and a blinking 30 appears in the viewfinder. This means the aperture selected requires 1/30 second for an optimum exposure. *The picture will be underexposed by one f-stop because the f-stop you selected requires a shutter speed of 1/30 second, and you are manually set for 1/60.*

- Continue to open the aperture until only the non-blinking 60 is displayed. *This is the correct combination of aperture and shutter speed for an optimum exposure.*

- If you open the aperture one more f-stop, a blinking 125 will appear. This means the aperture selected requires 1/125 second for an optimum exposure. *The picture will be overexposed by one f-stop because the f-stop you selected requires a shutter speed of 1/125 second, and you are manually set for 1/60.*

The basic steps for manual exposure are:

1. Set the film speed dial for the ISO film speed.

2. Set the shutter speed for your desired speed (1/60 for this example).
3. To meter, depress shutter release halfway.
4. Starting at f22, adjust aperture until only selected shutter speed is displayed. (In this example, 1/60 second.)
5. Check focus and take the picture.
6. To bracket to more exposure, adjust the aperture until you see a blinking 125 to the left of the 60 in the viewfinder.
7. To bracket to less exposure, adjust the aperture until you see a blinking 30 to the right of the 60 in the viewfinder.

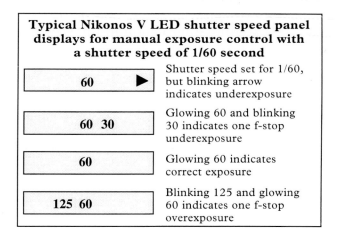

Typical Nikonos V LED shutter speed panel displays for manual exposure control with a shutter speed of 1/60 second

	
60 ▶	Shutter speed set for 1/60, but blinking arrow indicates underexposure
60 30	Glowing 60 and blinking 30 indicates one f-stop underexposure
60	Glowing 60 indicates correct exposure
125 60	Blinking 125 and glowing 60 indicates one f-stop overexposure

SELECTIVE EXPOSURE METERING

Selective exposure metering means metering off a selected part of the picture area. Use selective metering for scenes with a wide brightness range, from dark areas to light areas. If you meter off the darkest area, the picture will be overexposed. If you meter off the lightest area, the picture will be underexposed. Therefore, meter off an area of average brightness—not the darkest or the brightest.

SITUATION
SELECTIVE METERING,
MANUAL EXPOSURE CONTROL

Imagine that you are shooting a silhouette of your dive buddy posing in a crevice. You wish to expose for the blue water at the entrance (for average brightness), not the sides of the crevice.

1. Select a shutter speed (1/60 or 1/125).
2. Swim to the entrance and face the blue water.
3. Aim the camera at the blue water background.
4. Adjust the aperture so only the glowing 60 or 125 appears in the viewfinder display.
5. Enter the crevice, and aim the camera at the entrance.
6. Ignore the exposure information in the viewfinder display.
7. Adjust the focus and take the picture.

● ● ● ───────────────────────────

You metered selectively off the blue water at the mouth of the crevice. Thus, the diver silhouetted in the crevice will be properly exposed. Had you metered from deep inside the crevice, the dark walls would have caused the automatic exposure control to overexpose the mouth of the crevice.

─────────────────────────── ● ● ●

TOPSIDE PRACTICE

You can easily practice either A (auto) or manual exposure control topside with an empty camera. Here's how it's done:

1. Set the ISO film speed dial for 200.
2. Set the aperture for f22.
3. Look at a bright area (such as a window) through the viewfinder.

To avoid the effect of the dark crevice walls on the Nikonos V exposure metering system, I manually metered for the blue water background before swimming into the crevice.

4. Adjust the aperture and watch the LED displays (as discussed earlier in this chapter). Practice adjusting for the desired exposure setting.

Note: You may need to readjust the ISO film speed for your surrounding light conditions.

SITUATION
USING A SEPARATE EXPOSURE METER, MANUAL EXPOSURE CONTROL

Separate exposure meters, such as the Sekonic Marine Meter, are easier to use than the built-in metering system of the Nikonos V. The basic procedure is simple:

1. Preset the camera for the desired shutter speed.
2. Preset the separate exposure meter for the desired shutter speed and the ISO film speed.
3. Aim the separate exposure meter at the subject; aim at an area of average brightness.
4. Read the metered f-stop on the separate exposure meter. (Ignore the camera's viewfinder display.)
5. Set the Nikonos lens for the metered f-stop.
6. Adjust the focus and take the picture.

● ● ●

The Sekonic Marine Meter replaces the LED displays in the camera viewfinder. Because the Sekonic Marine Meter sees only a small part of the total picture area, it is excellent for selective exposure metering.

● ● ●

··· *12* ···

HOW TO TAKE NIKONOS V MANUAL STROBE EXPOSURES

This chapter deals with non-TTL Nikonos V strobe exposures for strobe-to-subject distances greater than two apparent feet. The procedures apply equally to 35, 28, 20 and 15mm lenses. Exposures for closer distances are included in Chapters 14-16.

USING MANUAL EXPOSURE CONTROL

A lthough TTL strobes are commonly used, I believe learning manual (non-TTL) exposure control first will help you master TTL later. To use manual control, you must know how to meter for the sunlight f-stop and how to find f-stops on a strobe exposure table.

TEST FLASH THE STROBE

Before loading film, attach the strobe with the sync cord and test flash the strobe by triggering the camera shutter. Advance to frame number one (film isn't needed), turn the strobe on and look inside the viewfinder. When you see the red lightning bolt (ready light) in the viewfinder, trigger the shutter to test the flash.

METERING FOR SUNLIGHT EXPOSURE

Nikon strobes. When you turn a Nikon strobe on, the

glowing 60 shown in the viewfinder (to indicate a shutter speed of 1/60 second) turns off. To meter for the sunlight aperture, start at f22, and rotate the aperture knob until you see a blinking 60. The blinking 60 means that the aperture is set for the sunlight exposure. To determine the f-number of the aperture selected, look at the lens aperture scale. *You may not get a blinking 60 in dark conditions. In this case, ignore the viewfinder display and use the strobe exposure table.*

Non-Nikon strobes. With some non-Nikon strobes, the glowing 60 (see above) doesn't turn off when the strobe is turned on. In this case, start at f22 and open the aperture until the glowing 60 is the only display you see. *Therefore, when this text tells you to adjust for a blinking 60, you will adjust for a glowing 60.*

METERING WITH A
SEPARATE EXPOSURE METER

If you have a separate exposure meter, such as the Sekonic Marine Meter, use it rather than the built-in exposure meter to determine the sunlight exposure. Ignore the exposure information shown in the viewfinder display.

● ● ●

A separate exposure meter frees you of the task of finding a blinking 60 and then looking at the lens to determine the sunlight f-stop. Simply point the meter at your subject and read the f-stop on the meter's scale.

● ● ●

Important procedure modifications. If you are using a separate exposure meter, modify the procedures in the following "situation" sections as follows:

1. Set the shutter speed for M90 (1/90 second). This turns the electronics off and saves battery life.

The Sekonic Marine Meter fits inside a metal mount. The mount can be attached to the strobe baseplate. (If necessary, drill and tap a 1/4-20 threaded hole in the baseplate.) I remove the screw which clamps the mount around the meter. Tightening this screw can crack the meter casing. The mount has enough tension to hold the meter in place without the screw.

2. Use the separate meter to determine aperture when the situation procedures tell you to "adjust for the blinking 60."

READING THE STROBE EXPOSURE TABLE

The strobe exposure table below was calculated with *The Secret Exposure Chart,* introduced in Chapter 5. I made it for a strobe with three power settings: full, 1/4 and 1/16 power. If your strobe has other settings, such as full, 1/2 and 1/4, you can use the *Secret Exposure Chart* and Example number 4 (in Chapter 5) to make your own personal exposure table. Remember that the exposure table is based on strobe-to-subject distance. Ignore changes in camera-to-subject distance.

SAMPLE STROBE EXPOSURE TABLE			
Distance Apparent Feet	Full Power	1/4 Power	1/16 Power
2 ft.	f11	f5.6	f2.8
3 ft.	f8	f4	f1.4
4 ft.	f5.6	f2.8	--
6 ft.	f4	f2	--
NB: If a diffuser is added, open each aperture one f-stop.			

● ● ● ─────────────────────────────

You can read the table two ways: You can locate the f-stop for a given strobe-to-subject distance, or you can locate the distance for a given f-stop. The strobe exposure table ignores sunlight. (It thinks it's on a night dive.)

───────────────────────────── ● ● ●

WHAT IS STROBE FILL

When the strobe light is weaker than sunlight, the strobe provides *fill lighting*. The weaker strobe light enhances colors and illuminates details in shadow areas. The resulting picture appears natural, but has a touch of color in the near subject areas.

SITUATION
SUNLIGHT WITH STROBE, WHAT F-STOP (WIPE TO THE RIGHT)

The goal is to select the correct f-stop. The picture will be exposed with the sunlight f-stop or strobe f-stop, depending on

which light source is the brightest. The weaker light source will provide fill lighting. While there are other methods, I believe this method is the simplest and fastest.

1. Set the film speed dial for the ISO film speed.
2. Set the shutter speed for 60.
3. Set the strobe for full power.
4. Estimate the strobe-to-subject distance. Select the f-stop from your strobe exposure table; *set the lens for this f-stop.*
5. Aim the camera at the subject and depress the shutter release halfway.
6. Verify that the ready light is glowing.
7. If you see any shutter speed to the left of the 60, adjust the aperture control until you only see the 60. Adjust the focus and take the picture. (This will produce a sunlight exposure with strobe fill.)
8. If you see only the 60, adjust the aperture so the 30 appears to the right of the 60, adjust the focus and take the picture. (Sunlight and strobe light will be equally balanced at the focused distance.)
9. If you see the 30 or a blinking arrowhead to the right of the 60, adjust the focus and take the picture. (This will produce a picture with brightly illuminated near subjects against a darkened background.)

Let's review the viewfinder displays for the above situation. Remember, you start with the f-stop shown on the strobe exposure table for the strobe-to-subject distance. Then, you meter to see the viewfinder display, and you adjust the aperture for the 60 or 60-30 display. *You wipe out the shutter speed display from the left to the right to obtain the desired aperture.*

● ● ●
The reason we adjusted from the 60 display to the 60-30 is because the sunlight and strobe light were equal at the 60 display. Because the two light sources add together and increase exposure, we closed the aperture one-half stop to prevent overexposure.
● ● ●

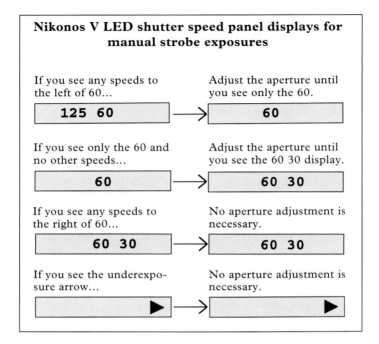

Nikonos V LED shutter speed panel displays for manual strobe exposures

If you see any speeds to the left of 60...

Adjust the aperture until you see only the 60.

125 60 → **60**

If you see only the 60 and no other speeds...

Adjust the aperture until you see the 60 30 display.

60 → **60 30**

If you see any speeds to the right of 60...

No aperture adjustment is necessary.

60 30 → **60 30**

If you see the underexposure arrow...

No aperture adjustment is necessary.

▶ → ▶

Taken at a distance of about six feet in sunlight, the strobe light barely reaches the barrel of this Japanese field gun on the deck of the Nippo Maru. *Thus, we have a sunlight exposure with weak strobe fill.*

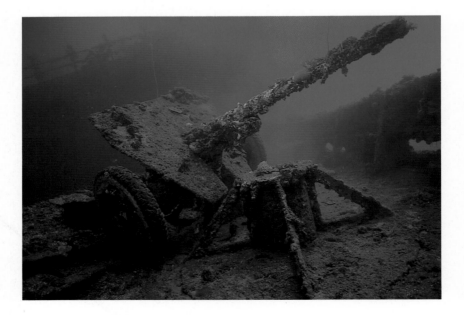

SITUATION
SUNLIGHT AND STROBE FILL

The goal is a sunlight exposure with strobe fill at least one stop weaker than sunlight. You can use this technique at virtually any distance.

1. Set the film speed dial for the ISO film speed.
2. Set the shutter speed dial for 60.
3. Set strobe to full power.
4. Aim camera and adjust the aperture for a blinking 60.
5. Look at the lens and see what f-stop you selected.
6. Look at the strobe table and note the f-stop for the distance.
7. Hold the strobe back (or reduce the power setting) so the strobe exposure (from the exposure table) is one stop weaker than the sunlight exposure.
8. Verify that the ready light is glowing.
9. Adjust the focus and take the picture.

Mike Mesgleski used the blinking 60 to determine the aperture of f8. Because the strobe exposure (from the strobe exposure table) indicated f5.6, Mike's diver portrait is a sunlight exposure with strobe fill. The "I'm confused" strobe fill method would have produced similar results.

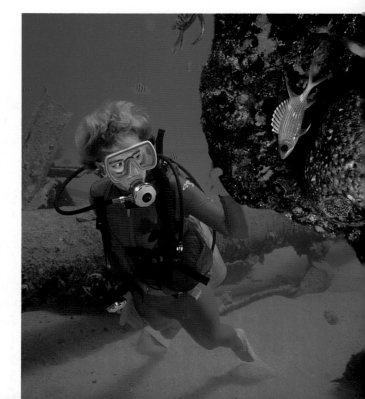

SITUATION
Bright Sunlight,
"I'm Confused" Strobe Fill

The goal is to KISS (keep it super simple). Let's assume that all the talk about exposure tables and strobe fill has confused you. If so, use the Jim Church "I'm confused" strobe fill procedure.

With power settings for full, 1/4 and 1/16 power:

1. Place the diffuser on your SB-102 or 103.
2. Set the film speed dial for the ISO film speed.
3. Set the shutter speed dial for 60.
4. Aim the camera at the subject.
5. Adjust the aperture so the 60 blinks in the viewfinder.
6. Verify that the ready light is glowing.
7. Think: "One, two and three."
8. If the closest part of your subject is one foot away, set your strobe for 1/16 power.
9. If the closest part of your subject is about two feet away, set your strobe for 1/4 power.
10. If the closest part of your subject is three or more feet away, set your strobe for full power.
11. Adjust focus and take the picture.

With power settings for full, 1/2 and 1/4 power:

1. Set the film speed dial for the ISO film speed.
2. Set the shutter speed dial for 60.
3. Aim the camera at the subject.
4. Adjust the aperture so the 60 blinks in the viewfinder.
5. Verify that the ready light is glowing.
6 Think: "Two, almost three and three."
7. If the closest part of your subject is two feet away, set your strobe for 1/4 power.
8. If the closest part of your subject is between two and three feet away, set your strobe for 1/2 power.
9. If the closest part of your subject is about three or more

feet away, set your strobe for full power.

10. Adjust focus and take the picture.

● ● ● ──────────────────────────────

Remember: The "I'm confused" method is only a quick esti-mate. If you make a mistake with your strobe power setting, it's better to underexpose with the strobe than to overexpose. You will still have a sunlight picture.

────────────────────────────── ● ● ●

SITUATION
BRIGHT SUNLIGHT, FAR AND NEAR SUBJECTS

The goal is to illuminate both far and near subjects. Imagine that you have two subjects: a silhouetted background diver and a near sponge. You want a sunlight exposure for the diver and distant background, but you want to use strobe light to brighten the near sponge. *Because you want the sunlight exposure in the background, sunlight will determine the aperture.* You, however, must choose the correct strobe-to-subject distance for the strobe exposure on the near sponge.

1. Set the film speed dial for the ISO film speed.
2. Set the shutter speed for 60.
3. Set the strobe for full power.
4. Aim the camera at the subject. Meter for a blinking 60 to set aperture for background exposure.
5. Look at the lens to see what aperture has been selected.
6. Look at the strobe exposure table and find correct dis-tance for aperture selected.
7. Hold the strobe at the strobe table distance from the near subject.
8. Verify that the ready light is glowing.
9. Adjust the focus and take the picture.

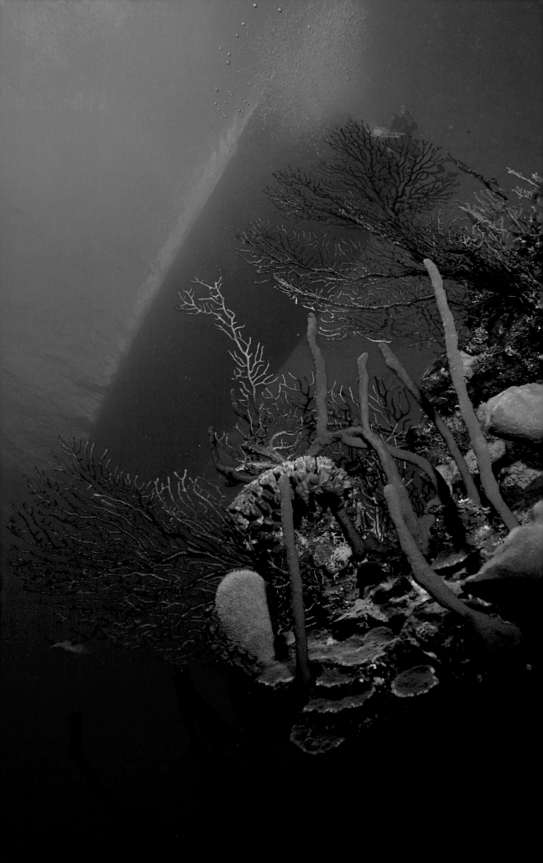

It was scary and dark inside the machine shop of the Shinkoku Maru. *I estimated the strobe-to-subject distance to the grinder by eye and used the f5.6 aperture from the strobe exposure table.*

SITUATION
IN THE DARK

The goal is to select the correct f-stop. In dark conditions, you won't see a blinking 60 in the viewfinder. The blinking arrowhead is all you see because there isn't enough sunlight for an exposure. The strobe will determine the exposure.

1. Set the film speed dial for the ISO film speed.
2. Set the shutter speed for 60.
3. Set the strobe for full power.
4. Select the f-stop from your strobe exposure table.
5. Verify that the ready light is glowing.
6. Adjust the focus and take the picture.

Gerald Freeman began with an exposure meter for the boat and blue background to determine the aperture, then held the strobe at the appropriate distance from the foreground for a balanced near/far exposure.

··· *13* ···

HOW TO TAKE NIKONOS V TTL STROBE EXPOSURES

This chapter deals with Nikonos V TTL strobe exposures for strobe-to-subject distances greater than two apparent feet. The procedures apply equally to 35, 28, 20 and 15mm lenses. Exposures for closer distances are included in Chapters 14-16.

IT'S REVIEW TIME

To avoid duplication of general information, please turn back and review Chapters 5-7, and the following sections from Chapter 12:

- Test flash the strobe
- Metering for sunlight exposure
- Metering with a separate exposure meter
- Reading the strobe exposure table
- What is strobe fill

In each of the situations presented, I will assume that you tested the TTL before loading film (Chapter 5), advanced to frame number one and verified that a LED display appears in the viewfinder before you load the film. Also, remember that the Nikonos V will synchronize with any strobe at shutter speeds up to 1/90 second. To get the 1/90 second, set the shutter speed dial for A and turn the strobe on. *You will look for a 125-60 display in the viewfinder rather than the 60 used in the situations.* TTL can be used with ISO film speeds from 25 to 400.

● ● ● ─────────────────────────────────

The procedures given for the TTL situations are often similar to the procedures for manual strobe control. Rather than try to combine manual and TTL, I have split these into two separate chapters to simplify the explanations. While this means repeating many situation steps, it makes the procedures easier to read and follow.

───────────────────────────────── ● ● ●

FULL-POWER FLASH SIGNAL

A rapidly blinking ready light (on the strobe and in the viewfinder display) means that the TTL strobe has delivered a full-power flash.

- If the strobe is providing fill lighting for a sunlight exposure, ignore the full-power flash signal.
- If the strobe is providing the light for the exposure (such as in the dark or for close-ups), a full-power flash signal may indicate underexposure. In this case open the aperture one-half stop, and shoot another picture. Continue this procedure until the strobe stops signaling a full-power flash.

SITUATION
SUNLIGHT WITH STROBE, WHAT F-STOP
(WIPE TO THE RIGHT)

The goal is to select the correct f-stop. The picture will be exposed with the sunlight f-stop or strobe f-stop, depending on which light source is the brighter. The weaker light source will provide fill lighting.

1. Set the film speed dial for the ISO film speed.
2. Set the shutter speed for 60.
3. Set the strobe for TTL.
4. Set the aperture for the f-stop from your strobe exposure table.

5. Verify that the ready light is glowing.
6. Aim the camera at the subject and depress the shutter release halfway.
7. If you see any shutter speed to the left of the 60, adjust the aperture control until you only see the 60. Adjust the focus and take the picture. (The full-power flash signal may or may not blink—ignore it.)
8. If you see only the 60, adjust the aperture so the 30 appears to the right of the 60, adjust the focus and take the picture. (The full-power flash signal may or may not blink—ignore it.)
9. If you see the 30 or blinking arrowhead to the right of the 60, adjust the focus and take the picture. (The full-power flash signal should not blink. If it does, bracket by opening the aperture.)

● ● ● ────────────────────────

The method of determining the f-stop is virtually the same as described below the same situation headline in Chapter 12. The only difference is that you set the strobe for TTL rather than for a full power.

──────────────────────── ● ● ●

SITUATION
Bright Sunlight,
"Church Correction" Strobe Fill

The goal is a sunlight exposure with strobe fill at least one f-stop weaker than the sunlight.

1. Set film speed for *double the ISO film speed.*
2. Set the shutter speed dial for 60.
3. Set the strobe for TTL.
4. To meter, adjust the aperture for the 125 display.
5. Verify that the ready light is glowing.
6. Adjust the focus and take the picture.
7. Ignore the full-power flash signal.

A cable hanging from the mast of the **Sankisan Maru** *in Truk Lagoon is adorned with sponges, all competing for space. I set the aperture for the f-stop from the strobe exposure table and pressed the shutter release halfway down. The 60 display appeared in the viewfinder, so I checked the focus and took the picture. Because the strobe illuminated the shadow side of the subject, I didn't have to close the aperture for the 60-30 display.*

By doubling the film speed, you are telling the TTL system to reduce the strobe's light output by one f-stop. By setting the shutter for 1/60, but selecting the 125 display in the viewfinder, you are compensating for the increase in ISO film speed. This method works up to the TTL automatic range. Beyond the auto range, the full-power flash still only produces strobe fill.

• • •

The "Church Correction" is my favorite technique for achieving strobe fill with a TTL strobe. The key idea is that the light output of the strobe will be at least one f-stop weaker than the sunlight exposure. This is an excellent technique that you can use anytime in bright conditions at distances greater than about two apparent feet.

• • •

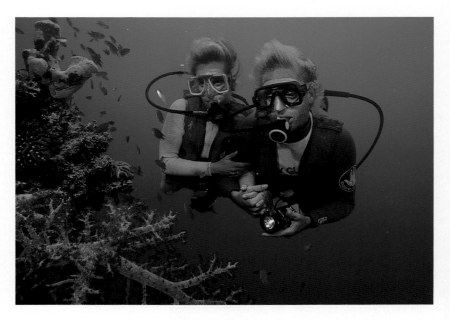

I used the "Church Correction" to reduce the amount of TTL strobe light striking Jeannie Wiseman and Kevin Davidson. Because the sunlight and strobe exposures were about the same, a normal TTL exposure could have overexposed their skin. I could have achieved the same result with the "I'm confused" strobe fill method (Chapter 12).

SITUATION
BRIGHT SUNLIGHT, TTL FILL, SEPARATE EXPOSURE METER

As above, the goal is a sunlight exposure with strobe fill at least one f-stop weaker than the sunlight. The only difference is that you are using a separate exposure meter rather than the meter in the camera body for this version of the *Church Correction*.

1. Set the film speed dial for *double the ISO film speed*.
2. Set the shutter speed dial for 60.
3. Set the meter for actual ISO and 1/60 second.
4. Set the strobe for TTL.

5. Read the f-stop from the meter and set this f-stop on lens.
6. Verify that the ready light is glowing.
7. Adjust the focus and take the picture.
8. Ignore the full-power flash signal.

● ● ● ────────────────────────────────

Because you doubled the ISO film speed setting, the TTL strobe will turn off one f-stop early. Because you set the aperture with a separate exposure meter set for the correct ISO film speed, the lens is set for the sunlight exposure. The result is a sunlight exposure with TTL flash fill one f-stop weaker than sunlight.

──────────────────────────────── ● ● ●

SITUATION
BRIGHT SUNLIGHT, FAR AND NEAR SUBJECTS

The goal is to illuminate both far and near subjects.

- If the subject is centered, use the procedure given in the *Sunlight and Strobe, What F-Stop* situation described earlier in this chapter.
- If the near subject is off-center (such as a distant diver and a near sponge), use the *Bright Sunlight, Far and Near Subjects* situation described in Chapter 12.

SITUATION
IN THE DARK

If you are inside a sunken wreck, dark lava tube or shooting at night, don't bother looking for the blinking 60 in the viewfinder display. All you will see is the arrowhead underexposure warning. The same applies to close-ups when the strobe overpowers sunlight. Set the aperture for the f-stop shown on your strobe exposure table for the strobe-to-subject distance.

1. Set the film speed dial for the ISO film speed.

Working in semi-darkness, I set the aperture for the f-stop from my strobe exposure table, and set the strobe for TTL. I bracketed exposures with the ISO film speed dial. The middle exposure was correct—ta da!

2. Set the shutter speed dial for 60.
3. Set the strobe for TTL.
4. Estimate the strobe-to-subject distance.
5. Set the aperture for the f-stop from your strobe exposure table.
6. Verify that the ready light is glowing.
7. Adjust the focus and take the picture.
8. If the full-power flash signal blinks, open the aperture one-half stop and shoot again.

··· *14* ···

How To Take Nikonos V Wide-Angle Close-Ups

"I've had this 15mm lens for years, but have never done anything like this!" This was a statement made by one of my underwater photography students. He had taken 15mm wide-angle close-ups, at about six to eight inches from his dome port, at night and without the viewfinder. He was pleasantly surprised with the results.

What Are Wide-Angle Close-Ups

Nikonos V wide-angle close-ups are taken with a 20mm or 15mm lens at minimum distance. Wide-angle close-ups differ from close-ups with supplementary close-up lenses (such as the Nikonos close-up outfit) or extension tubes. You can show close-up views of subjects that otherwise would be too large for the Nikonos close-up outfit.

Mounting the Strobe

If using the Nikonos arm and bracketing system for the Nikon SB-102 or SB-103, proceed as follows:

1. Attach the baseplate to the camera body.
2. Attach the strobe arm so it tilts toward the camera body.
3. Attach the strobe so it is on the inside of the arm, over the camera body.

4. Slide the strobe up until the strobe-mounting knuckle is at the top of the arm.

● ● ● ─────────────────────────────

Use the diffusers with the SB-102 or SB-103 to spread the beam over the entire wide-angle picture area. If you are handholding the strobe, hold it about one foot above the camera and aim it down toward the close-up subject. Once the strobe-to-subject distance is established, use your personal exposure table (Example 4, Chapter 5) to select the f-stop.

───────────────────────────── ● ● ●

AIMING THE CAMERA

I use a version of the water pistol technique (Chapter 10) when aiming for 20mm and 15mm wide-angle close-ups. From about one foot behind the camera, I first look at the subject in the frame formed by the strobe arm, baseplate and left side of the camera body. Next, I move the camera to the left until the back of the camera body is in front of my eye, and then take the picture. At night, I leave the viewfinder topside as it only blocks my view of close-up subjects.

● ● ● ─────────────────────────────

Beginners have a hard time leaving the viewfinder behind. But after you gain experience, the "point and shoot" style of aiming the camera gets easier. Look directly at the subject. Hold the camera about a foot in front of your face, and look "through" the camera body. Then, take the picture.

───────────────────────────── ● ● ●

SITUATION
20MM WIDE-ANGLE CLOSE-UPS, TTL EXPOSURE CONTROL

The goal is to take 20mm wide-angle close-ups at minimum distance. Estimate camera-to-subject distance by touching the left side of the camera body to the inside of your left elbow. When

you extend your arm and outstretched fingers, your fingertips will reach the focused distance. Be sure to pull your hand back before taking the picture! Aim the camera either with the viewfinder, or with the water pistol technique.

1. Mount the strobe above the camera.
2. Set the strobe for TTL.
3. Set the ISO film speed one mark past the ISO speed of the film. (See Fine Tuning TTL Exposures in this chapter.)
4. Set the shutter speed dial for 60.
5. Set the focus for 1.3 feet (minimum distance).
6. Set the aperture for the f-stop from the exposure table.
7. Estimate distance (inside elbow to fingertips).

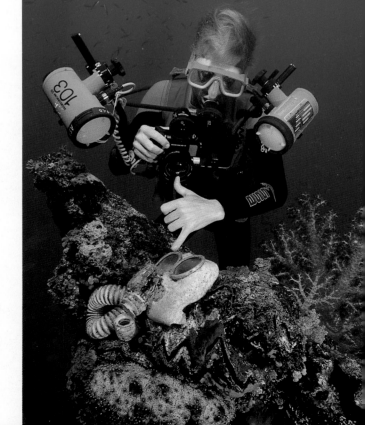

To estimate close-up distance with the 15mm lens, touch your thumb to the dome port and your little finger to the subject. (Just choose a subject that won't bite you.) When using two strobes, mount to the left and right, and above the camera.

8. Verify that the ready light is glowing.
9. Aim and take the picture.
10. If the full-power flash signal blinks, open the aperture one-half f-stop and try again.

●●● ─────────────────────────────

To see why I set the ISO film speed one mark past the actual ISO rating, see "Fine Tuning TTL Exposures," below.

───────────────────────────── ●●●

SITUATION
15MM WIDE-ANGLE CLOSE-UPS, TTL EXPOSURE CONTROL

The goal is to take 15mm wide-angle close-ups at minimum distance. You can work as close as eight inches from the front of

I set the aperture for f11 (which matched the upward-angle, blue water background) and aimed the TTL strobe upward at the underside of the soft coral. This technique provided balanced sunlight and strobe exposures.

the dome port. Estimate camera-to-subject distance by stretching your thumb and little finger apart. Touch the thumb to the front of the lens port, and your little finger will touch the focused distance. Be sure to pull your hand out of the way before you take the picture. While the viewfinder has markings for one foot, I find the "water pistol method" the most practical method of aiming the camera.

1. Mount the strobe above camera.
2. Set the strobe for TTL.
3. Set the ISO film speed one mark past the ISO speed of the film.
4. Set the shutter speed dial for 60.
5. Set the focus for 1 foot (minimum distance).
6. Set the aperture for the f-stop from the exposure table.
7. Estimate distance (thumb to dome, little finger to subject).
8. Verify that the ready light is glowing.
9. Aim and take the picture.
10. Bracket exposures with either the f-stop or varying the strobe-to-subject distance.

Fine Tuning TTL Exposures

TTL full-power flash signal. You can find the optimum combination of aperture and strobe distance by watching the strobe ready light. Vary the aperture or strobe distance until the strobe ready light blinks to signal a full-power flash. Then, open the aperture one-half f-stop or reduce the strobe distance.

TTL exposure compensation. Set the ISO dial one mark past the actual ISO speed of the film. With ISO 64 film, for example, set the dial for ISO 80. With ISO 100 film, set the dial for ISO 125. This increase in film speed tells the TTL to underexpose the film by one-third stop. *The purpose of this underexposure is to prevent small, bright subject areas from overexposing.*

TTL bracketing. You can bracket exposures by changing the ISO setting of the camera film speed dial. For more exposure, decrease the ISO film speed setting. For less exposure, increase the ISO film speed setting.

MANUAL EXPOSURE CONTROL

Although most of the steps for manual exposures are the same as for TTL exposures, I am presenting manual exposures separately so you can follow the steps as easily as possible. You should, however, read the introductory paragraphs of the TTL situations.

Perched about six inches from my dome port, this banded coral shrimp assumes monster proportions in this 15mm wide-angle close-up.

Wide-angle close-ups allow you to get close to artifacts. By getting closer, you minimize the amount of water (and suspended particles) you must photograph through.

SITUATION
20MM WIDE-ANGLE CLOSE-UPS, MANUAL EXPOSURE CONTROL

The goal is to take 20mm wide-angle close-ups at minimum distance.

1. Mount the strobe above the camera.
2. Set the strobe for M FULL.
3. Set the ISO film speed (as a reminder only).
4. Set the shutter speed dial for M90.
5. Set the focus for 1.3 feet (minimum distance).
6. Set the aperture for the f-stop from the exposure table.
7. Estimate distance (inside elbow to fingertips).
8. Verify that the ready light is glowing.

9. Aim and take the picture.
10. Bracket exposures with either the f-stop or varying the strobe-to-subject distance.

SITUATION
15MM WIDE-ANGLE CLOSE-UPS, MANUAL EXPOSURE CONTROL

The goal is to take 15mm wide-angle close-ups at minimum distance.

1. Mount the strobe above the camera.
2. Set the strobe for M FULL.
3. Set the ISO film speed (as a reminder only).
4. Set the shutter speed dial for M90.
5. Set the focus for one foot (minimum distance).
6. Set the aperture for the f-stop from the exposure table.
7. Verify that the ready light is glowing.
8. Estimate distance (thumb to dome, little finger to subject).
9. Aim and take the picture.
10. Bracket exposures with either the f-stop or by varying the strobe-to-subject distance.

··· *15* ···

HOW TO USE
THE NIKONOS
CLOSE-UP OUTFIT

Close-ups are truly exciting. At Truk Lagoon, you could spend an entire dive photographing a colorful clown fish and take home some fantastic shots. This chapter will introduce you to Nikonos V close-ups with the Nikonos close-up outfit.

THE NIKONOS CLOSE-UP OUTFIT

The Nikonos close-up outfit is the most commonly used close-up lens system with the Nikonos camera. It consists of four main parts:

- A close-up lens that fits over the Nikonos 28mm, 35mm or 80mm lens.
- A support rod to help secure the close-up lens to the camera body.
- A framer support rod.
- Three interchangeable field framers for the 28mm, 35mm and 80mm lenses.

● ● ● ────────────────────────────────

Although the close-up outfit includes (at this writing) a framer for the 80mm lens, the 80mm lens is no longer in production.

──────────────────────────────── ● ● ●

The same close-up lens is used with all three of the lenses mentioned above. The only difference is that you select the

framer that matches the lenses used. There is a small (10mm) space between the edge of the picture area and the inside of the framer.

The picture areas and reproduction ratios for the close-up outfit, when used with the 28mm, 35mm and 80mm lenses are listed below:

- With the 28mm lens: 5.68 x 8.51 inches (1:6)
- With the 35mm lens: 4.30 x 6.38 inches (1:4.5)
- With the 80mm lens: 2.09 x 3.11 inches (1:2.2)

ATTACHING THE CLOSE-UP OUTFIT

Attaching the Nikonos close-up outfit to the camera body is easy:

1. Attach the support rod to the viewfinder shoe.
2. Preset the camera lens for infinity.
3. Loosen the locking screw on the side of the close-up lens.
4. Slip the close-up lens in place over the camera lens. Lay the camera body on its back and wiggle the close-up lens to make sure it is seated correctly.
5. Tighten the knobs on the support rod and the base of the close-up lens. Use firm finger pressure, but don't overtighten. "Gorilla fingers" can break the locking screw.
6. Slide the framer support rod into the mounting shoe at the bottom of the close-up lens. Tighten with finger pressure.
7. Attach the field framer for the lens used. Note: The lens designation is imprinted at the upper rear of the framer. It faces the camera.

MOUNTING THE STROBE

If using the Nikonos arm and bracketing system for the Nikon SB-102 or SB-103, proceed as follows:

The tightening screw of the close-up lens is weak and is often damaged by corrosion. I usually use a strong rubber band or O-ring to help secure the close-up lens over the primary lens.

1. Attach the baseplate to the camera body.
2. Attach the strobe arm so it tilts toward the camera body.
3. Attach the strobe so it is on the inside of the arm, over the camera body.
4. Slide the strobe down so about three inches of arm protrude through the strobe-mounting knuckle.

● ● ● ─────────────────────────────────────

By mounting the strobe above the camera, it will be aiming downward to the center of the framer. Thus, if photographing a fish, it doesn't matter which way the fish is facing. Its face will be lit. Side lighting from the upper left corner causes framer shadows to appear in your pictures.

───────────────────────────────────── ● ● ●

SITUATION
Close-Ups with TTL

The goal is to take TTL close-ups. The following steps are for the Nikonos with Nikonos close-up outfit. These steps also apply to other close-up lenses:

1. Mount the strobe above the camera.

2. Set the film speed dial for one mark past actual ISO rating.
3. Set the shutter speed dial for 60.
4. Adjust focus for infinity.
5. Set the aperture (see Example 3, Chapter 5).
6. Set the strobe for TTL.
7. Verify that the ready light is glowing.
8. Aim with the framer and take the picture.
9. If the full-power flash signal blinks, open one-half stop and try again.

● ● ●

To find out why I set the film speed dial one mark past the actual ISO rating, see "Fine Tuning TTL Exposures," in Chapter 14.

● ● ●

Mike Mesgleski uses a cheese can to lure yellowtail snapper into his close-up framer. Small amounts of cheese don't seem to harm fish. If it did, thousands of seventeenth-generation "cheese-can fish" wouldn't be alive and thriving in Grand Cayman.

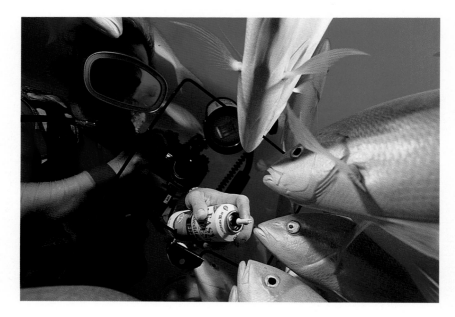

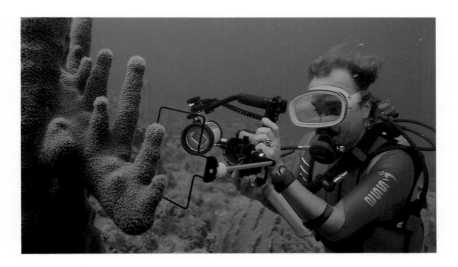

Aim the close-up lens by placing the framer around your subject. Don't look through the camera viewfinder.

SITUATION
CLOSE-UPS WITH
MANUAL EXPOSURE CONTROL

The goal is to take close-ups with manual exposure control. The following steps are for the Nikonos with Nikonos close-up outfit. These steps also apply to other close-up lenses:

1. Mount the strobe above the camera.
2. Set the film speed dial for ISO film speed (for a reminder only).
3. Set the shutter speed dial for M90.
4. Adjust focus for infinity.
5. Set the aperture (see Example 3, Chapter 5).
6. Set the strobe for M FULL.
7. Verify that the ready light is glowing.
8. Aim with the framer and take the picture.
9. If you are hand-holding your strobe, you can bracket by varying the strobe-to-subject distance. If bracketing with aperture, try half f-stop intervals.

Close-Up Depth of Field

Depth of field diminishes quickly with reduced picture areas, even when high-numbered f-stops are used. Using the Nikonos close-up outfit depth of field specifications as examples, we find depth of field to be as follows:

- 28mm lens at f22: 3.1 inches (-1.3 to + 1.8 inches)
- 28mm lens at f16: 2.2 inches (-0.1 to + 1.2 inches)

- 35mm lens at f22: 1.9 inches (-0.9 to + 1.1 inches)
- 35mm lens at f16: 1.4 inches (-0.6 to + 0.8 inches)

- 80mm lens at f22: 0.4 inches (-0.2 to + 0.2 inches)
- 80mm lens at f16: 0.3 inches (-0.1 to + 0.2 inches)

The first number in inches indicates the total depth of field. The minus number indicates the depth of field on the near side of the focused distance, the plus number indicates the depth of field beyond the focused distance.

Aiming With and Without the Framers

The framers are great for subjects that fit within the framer and for friendly fish that can be enticed to pose within the framer with bait. The framers are a disaster for subjects that can't be placed within the framer, or marine life that is afraid of its presence.

Remove the framer to avoid bumping subjects and to photograph subjects lurking in crevices or that are frightened by the framer. Using the close-up outfit without the framers, however, requires practice, but can be learned in three easy steps:

Mike Mesgleski held his close-up framer flush against the opening in the sea fan, and I used a cheese can to lure the angelfish into the opening. The TTL exposure was perfect.

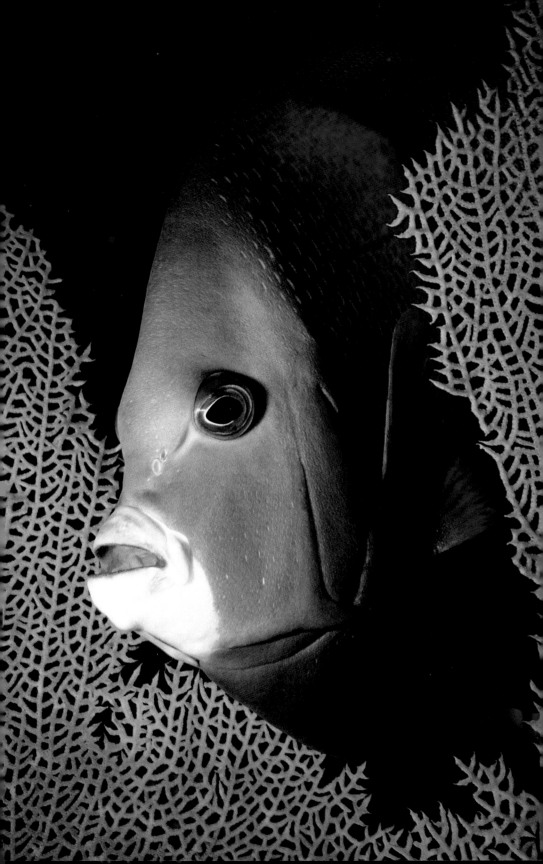

1. Use the framer until you can visualize the picture area framed.
2. Practice removing the framer. Hold the framer up to a subject and see where the end of the support rod would be. Then lay the framer aside (but don't lose it).
3. After you can visualize picture area, start removing the support rod. Estimate distance by extending your left fingertips toward a subject and touching the camera body to your left wrist.

●●● ───────────────────────────────

Estimating where the center of the picture will be, when using the support rod without the framer, is easy. Touch your left thumb to the rod and your first finger to the center of the close-up lens. Then, slide your hand down to the end of the rod. Your fingertip will be at the center of the picture.

─────────────────────────────── ●●●

Using Diffusers

The Nikon SB-102 and SB-103 are supplied with plastic diffusers to widen the beam. With the 28mm lens and framer, a diffuser spreads the light more evenly over the picture area. However, the diffuser weakens the strobe intensity by one f-stop. With the 35mm and 80mm lenses and framers, the diffuser isn't needed. With any lens, a diffuser usually produces slightly warmer colors.

Another aiming option is the "Spot Shot" by Underwater Photo-Tech. The two narrow beams of the spotting lights converge at the center of the picture area.

··· *16* ···

How To Use Nikonos V Extension Tubes

Something moved inside the neck of the bottle. My first impulse was to ignore it, but I weakened and took a closer look. It was a tiny octopus.

What Are Extension Tubes

Extension tubes are metal cylinders that fit between the Nikonos camera body and the Nikonos lens. Extension tubes reduce the focused distance of the Nikonos lens to only a few inches. The advantage of extension tubes is that they allow you to fill your picture with portraits of tiny marine creatures that would be lost in the picture areas of some close-up lenses. The disadvantage is that once an extension tube is installed, you must return to the surface to change or remove it.

Extension Tube Sizes

The three most common sizes are 1:1 (one to one), 1:2 (one to two) and 1:3 (one to three). Sometimes two tubes are stacked together to form a 2:1 tube. These sizes are called *reproduction ratios, image ratios* or *image sizes*. The first number refers to the image size on film. The second number refers to the subjects real-life size. A 1:3 tube photographs a picture area about three inches high. A 1:2 tube photographs a picture area about two inches high. A 1:1 tube photographs a picture area about one inch high. A 2:1 tube photographs a picture area about one-half inch high.

This tiny octopus peeked at me through the transparent neck of the bottle. I framed him with my 1:3 extension tube and hoped that the glass wouldn't cause any distracting reflections.

You can identify extension tube sizes by looking at the heights of the sides of the framers:

- A 1:3 extension tube aiming framer is about three inches in height.
- A 1:2 extension tube aiming framer is about two inches in height.
- A 1:1 extension tube aiming framer is about one inch in height.
- A 2:1 extension tube aiming framer is slightly less than one inch in height.

● ● ● ───────────────────────────────

I used the weasel word "about" in the above section because the measurements aren't always accurate. Manufacturers have rounded measurements in a sloppy manner. A 1:3 tube, for example, may actually be a 1:2.75 tube.

─────────────────────────────── ● ● ●

While the same extension tubes can be used with both 35mm and 28mm lenses, the framers differ. The framer for a 28mm lens must be wider because the 28mm lens has a wider picture angle, and is shorter because the 28mm lens focuses closer. Some manufacturers offer different framers (for the same tubes) for 35mm and 28mm lenses.

Installing the Tube

The Nikonos lens is a "push-turn" fit onto the front of the extension tube, and the extension tube is a "push-turn" fit onto the camera body. The "push-turn" fit is the same movement that you would use to attach a lens to a camera body. Most extension tubes lack guide pins, such as the guide pins that keep a lens aligned. Thus, you must align the tube by eye.

● ● ●

In air, an extension tube tends to wobble slightly when attached to the camera body. This is normal. Underwater, sea pressure presses it in place.

● ● ●

Mounting the Strobe

If using the Nikonos arm and bracketing system for the Nikon SB-102 or SB-103, mount the strobe over the camera body.

1. Attach the baseplate to the camera body.
2. Attach the strobe arm so it tilts toward the camera body.
3. Attach the strobe so it is on the inside of the arm, over the camera body.
4. Slide the strobe down so about four or five inches of arm protrude through the strobe-mounting knuckle.

Strobe-to-framer distance is important. As a starting point, you can position the strobe so it is approximately the same distance to the framer as the film speed control knob. For more precise information, see *The Secret Exposure Chart*, in Chapter 5.

Aiming with the Framer

The framer is a crude aiming device, but allows you to take pictures quickly, with minimum equipment. With tiny, moving subjects, a Nikonos V and extension tube is often easier to use

than a Nikonos RS and 50mm macro lens.

The picture is partially surrounded by a framer that extends across the bottom and up the two sides of the subject. There is a small "dead space" between the edge of the picture area and the framer. This space prevents the framer from showing up in the picture if the framer is bent.

Because the dead space between picture and framer is usually unknown and unevenly distributed, framing the subject can be difficult. Take some test pictures of a flat target to determine the exact picture area boundaries. Then, mark these boundaries on the framer.

● ● ● ———————————————————————————————

The point of sharpest focus is usually flush with the outside edge of the framer when the Nikonos lens is set for minimum focus. At infinity, the point of sharpest focus is a few millimeters beyond the framer.

——————————————————————————————— ● ● ●

SITUATION
EXTENSION TUBE WITH TTL

The goal: TTL extension tube exposures. TTL works well with extension tube photography. Just make sure that your subjects fill the center of the framed area.

You aim the extension tube by centering the subject flush within the borders of the focal frame. Note that Mike has marked the borders of the picture area on the framer. He has also cut most of the left upright off so he can sidelight without casting a shadow on his subject.

1. Set the film speed dial for one mark past the actual ISO film speed.
2. Set the shutter speed dial for 60.
3. Set the aperture for f22 (f16 for 2:1 tube).
4. Set the focus for minimum distance.
5. Mount (or hold) the strobe 6 to 9 inches from framer.
6. Verify that the ready light is glowing.
7. Aim with the framer and take the picture.
8. If the full-power flash signal blinks, move strobe in closer.

● ● ● ————————————————————————

To find out why I set the film speed dial one mark past the actual ISO rating, see "Fine Tuning TTL Exposures" in Chapter 14.

———————————————————————— ● ● ●

Jeannie Wiseman photographed this tiny cowrie with a 1:1 extension tube and TTL exposure control. (Good work, Jeannie, I can't even see things that small.)

MANUAL STROBE EXPOSURES

Set the lens for f22 (f16 with the 2:1 tube) and control the exposure by varying the strobe-to-subject distance. See *The Secret Exposure Chart* in Chapter 5 for strobe-to-subject distances.

SITUATION
EXTENSION TUBE, MANUAL EXPOSURES

The goal: manual extension tube exposures. Manual exposure control is often best for creative lighting, such as side, top or back lighting, where the strobe isn't aimed at the front of the subject.

1. Mount the strobe above the camera.

2. Set the film speed dial for ISO film speed (reminder only).
3. Set the shutter speed dial for M90.
4. Set the focus for minimum (unless manufacturer's instructions say different).
5. Set the aperture at f22 (f16 for stacked 2:1 tube).
6. Set the strobe for full power.
7. See Examples 1 and 2, Chapter 5, for strobe distance.
8. Verify that the ready light is glowing.
9. Aim with the framer and take the picture.
10. To bracket exposures, vary strobe-to-subject distance.

Depth of Field

Extension tube depth of field is extremely shallow. About half the depth of field is in front of the point of sharpest focus, and half behind this point when extension tubes are used. (See Depth of Field in Chapter 3.) With the Nikonos lens set for f22, the approximate depth of field is as follows:

- 1:3 tube: 3/4 inch
- 1:2 tube: 3/8 inch
- 1:1 tube: 3/16 inch
- 2:1 tube: 3/32 inch

After Mike Mesgleski maneuvered this sea horse into position, I photographed it with a 1:2 extension tube and manual exposure control. These delicate creatures must be handled with extreme care.

Why the Strobe Is so Close

When you focus close enough for the reproduction ratio to appear in the focused distance port of the 50mm lens, you are working with *effective apertures.* Although you set the lens aperture for f22 (the relative aperture), the effective aperture is higher. This is why you must hold the strobe so close to the subject. The following chart shows the effective apertures for various extension tubes:

- At 2:1 - f22 = f64 (3 stops increase)
- At 2:1 - f16 = f45 (3 stops increase)
- At 1:1 - f22 = f45 (2 stops increase)
- At 1:2 - f22 = f32 (1 stop increase)
- At 1:3 - f22 = f29 (2/3 stop increase)

Because the strobe-to-subject distance may be only a couple inches with a 2:1 tube and f22, you may find it easier to aim the strobe if you use f16 with the 2:1 tube.

Flashmeter Testing

You can use a flashmeter, topside in air, to determine the strobe distance for average subjects. (See "Flashmetered Tables", Chapter 5). The goal is to find the correct strobe-to-subject distance. Proceed as follows:

1. Review Flashmetering from Chapter 5.
2. Pretend you are taking a picture of the flashmeter's sensor. Place the framer over the sensor. Aim the strobe at the sensor and flash the strobe with the camera shutter release.
3. Place the flashmeter sensor in the framer.
4. Vary the strobe-to-shutter distance until the flashmeter reading equals *the effective aperture* for the extension tube you are using.

Part

··· 5 ···

How To
Use The
Nikonos RS

MAKING FRIENDS WITH THE NIKONOS RS CAMERA BODY

*The Nikonos RS camera is a long-awaited develop-
ment. It is the first 35mm SLR developed for underwater
photography. Will it replace the Nikonos V camera? At
this writing, I would say no. The Nikonos RS is a higher-
quality, higher-priced camera for those who will pay more
for its advanced features.*

WHAT'S NEW

The most significant new feature is that the Nikonos RS is
the first amphibious 35mm SLR camera that offers the
basic features of topside SLR cameras. When compared to the
Nikonos V camera body, the Nikonos RS has both significant
improvements as well as additional features in the "bells and
whistles" department. At a glance, the new features are (in
alphabetical order):

- Aperture priority automatic
- Autofocus
- Automatic film threading
- Automatic ISO indexing
- Built-in motor drive
- Camera slave flash (SB-104 only)
- Center-weighted manual exposure
- Center-weighted TTL sensor
- Exposure compensation dial
- Matrix metering for A (auto) and flash fill

- Power film rewind
- Rear curtain sync option
- SLR viewfinding and focusing
- Strobe sync up to 1/125-second

The "bells and whistles" include:

- Autofocus not possible: Autofocus indicator blinks.
- Autofocus searching for focus: Autofocus indicator dot disappears.
- Exposure warning in A (auto): Analog display appears in viewfinder.
- Film is rewound: Film counter light blinks green.
- Film loaded incorrectly: "Err" in viewfinder; film counter light blinks red.
- Shutter speed set to L (lock): No indicators appear in viewfinder.
- Non-DX film when set for DX: "Err" appears in viewfinder; DX/ISO indicator blinks red.
- Out of film: "End" appears in viewfinder; film counter light blinks red.
- Strobe flashed at full power: Ready light blinks in viewfinder.
- Strobe is recycled: Ready light glows in viewfinder.

The Nikonos RS camera body is the most versatile 35mm amphibious camera currently available.

Viewfinder Displays

An amazing amount of information is shown in the LED displays of the Nikonos RS viewfinder. Let's pause and review these displays.

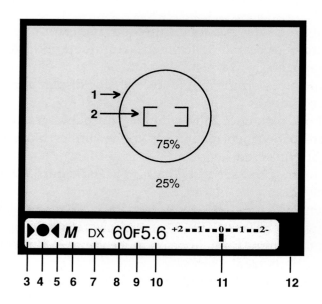

1. The 12mm circle indicates 75 percent of the sunlight exposure metering when the aperture is set for manual shutter speed. When using a TTL strobe, the TTL only responds to the area within this circle.
2. Focusing brackets. The subject area you focus on must be within these brackets.
3. Right-aiming arrowhead indicates that the focus is behind the subject.
4. The focusing dot glows when the lens is in focus and blinks when the lens is out of focus.
5. Left-aiming arrowhead indicates that the focus is in front of the subject.
6. The "M" indicates that a shutter speed has been set manually. An "A" will appear when the shutter speed dial is set for A (auto).

7. DX indicates that the film speed is set automatically when you use DX coded film.
8. The shutter speed selected; 1/60 second in this example.
9. The "F" stands for "f-stop."
10. The f-stop selected; f5.6 for this example.
11. The analog exposure display appears when you select a shutter speed manually.
12. (Not shown) A red, crooked arrow appears here when the strobe is recycled.

FOCUSING MODE SELECTOR DIAL

Get your camera and locate the focusing mode selector dial. The focusing mode selector dial has four positions: C, S, F and P. To activate the autofocus system, press the shutter release halfway. We will learn how to operate each focusing mode in Chapter 19.

The RS camera body controls can be viewed comfortably from above and behind the camera body. From left-to-right, you can see the exposure compensation dial, shutter speed dial, film frame counter and shutter release button.

Setting the Shutter Speed Dial

The shutter speed dial is an important input device that allows you to communicate with the Nikonos RS camera:

- Set the dial for L (lock), and the camera's electronics are shut off.
- Set the dial for A (auto), the matrix metering and aperture-priority automatic exposure controls are turned on.
- Set the dial for a shutter speed, and the center-weighted manual exposure mode is turned on.

Setting the Aperture Dial

The aperture dial is marked in consecutive full f-stops from f2.8 to f22. The dots (and click stops) between the full stops are for half-stops. Use the aperture dial to bracket exposures when the camera is set for the manual mode (when you set a shutter speed on the shutter speed dial).

Setting the Exposure Compensation Dial

The exposure compensation dial is marked in one-third f-stop (one-third EV value) increments. You can set the dial to increase or decrease exposure by two f-stops. Use the exposure compensation dial to bracket exposures when you are using TTL or A (auto).

Rewinding and Loading Film

Let's assume that you are reloading the camera after shooting a roll of film. Proceed as follows:

1. Wipe any water from the camera, your hands, face and hair.
2. Tilt the camera back downward, toward you, and open the camera back.

3. Look at the O-ring sealing surface. Wipe off any water droplets.
4. Press the film rewind lever. When the motor noise stops, the film is rewound.
5. Open the inner cover and remove the film.
6. Insert the new film cassette. The end of the film should reach the red index mark of the take-up spool.
7. Close the inner cover.
8. Make sure the rear curtain sync switch is in the "normal" position, then close the camera back.
9. Set the shutter speed dial for A or a shutter speed, and press the shutter release. You will hear three advances, and the film frame counter advances to frame one.

Note: If the film doesn't load correctly, you won't hear the three advances, a warning light will blink in the film counter window, and the letters "Err" (error) will appear in the viewfinder display.

• • • ────────────────────────────────
Always inspect the camera back O-ring before closing the door. A human hair on an O-ring can cause a flood. If the camera back feels stiffer than normal when you close it, add a small amount of silicone grease to the O-ring.
──────────────────────────────── • • •

Is There Film in The Camera

The film counter advances when the shutter is triggered if there is film in the camera or not. To quickly see if there is film in the camera, press the shutter release button halfway. If the warning light blinks in the frame counter window, the camera is empty.

• • • ────────────────────────────────
If you've forgotten what kind of film is in the camera, open the camera back, but don't open the inner cover. You see the information on the film cassette through a small window in the inner cover.
──────────────────────────────── • • •

Loading Non-DX Coded Film

To load with non-DX film, proceed as follows:

1. Raise the exposure compensation dial and set it for the ISO mark.
2. Look into the viewfinder and depress the shutter release button.
3. Move the power focus control (left or right) until you see the desired ISO film speed in the viewfinder display.
4. Reset the exposure compensation dial to zero.

● ●
When you switch back to DX-coded film, you must reset the camera for DX. Simply repeat the above procedure until you see "DX" in the viewfinder in place of an ISO film speed.
● ● ●

Double Checking the Camera

Before donning your dive gear and heading out to take pictures, check each of the following:

1. Strobe is connected and test flashed before film is loaded. (Set the focus mode selector to P, and you can trigger the shutter without having to focus the camera lens.)
2. Load the camera with film. (See the above two sections.)
3. Rear curtain sync is set for normal.
4. No warning lights in film counter window, or error message in the viewfinder when shutter release is depressed.
5. Exposure compensation dial is set for zero (unless you specifically want more or less exposure).
6. Focus mode switch is set for the desired focus.
7. Test the autofocus by focusing on a topside subject.
8. Shutter speed dial is set for L (lock). You can select A or a manual shutter speed at the time you enter the water.

● ● ● ─────────────────────────────

If the strobe won't flash, let's correct the problem before loading the camera with film. This prevents you from wasting film while test flashing the strobe. Even if the strobe has a test flash button, I prefer testing with the camera shutter release.

───────────────────────────── ● ● ●

··· 18 ···

NIKONOS RS
NIKKOR LENSES

The Nikonos RS AF Nikkor lenses are the first Nikonos auto-focus lenses. These lenses are compatible with—and only with—the Nikonos RS camera body.

A ll four of these new lenses have a distance scale window on top of the lens casing. You can look in and read the focused distance scale. These scales show both feet and meters, and the 50mm lens shows image (reproduction) ratios from 1:1 to 1:10. A built-in light illuminates the distance scales during focusing. This is a great help when you are using power manual focus in dark conditions.

• • •

The 18mm, 20-35mm and 13mm lenses are optically corrected for underwater; they produce blurry pictures in air. The 50mm lens has a flat port and can be used in air.

• • •

RS LENS COMPARISON CHART				
RS Lens	**Aperture Range**	**Minimum Focus***	**Minimum Image Ratio**	**Picture Angle****
13mm	f2.8-f22	6 in.	n/a	170 Degrees
28mm	f2.8-f22	10 in.	1:6 (6x9")	59.8 Degrees
35-20mm	f2.8-f22	14 in.	1:10 (10x15")	79-51 Degrees
50mm	f2.8-f22	7 in.	1:1 (1x1.3")	35 Degrees

**Minimum focus measurements have been rounded to the nearest inch.*
***The underwater picture angle is the angle of view the camera sees.*

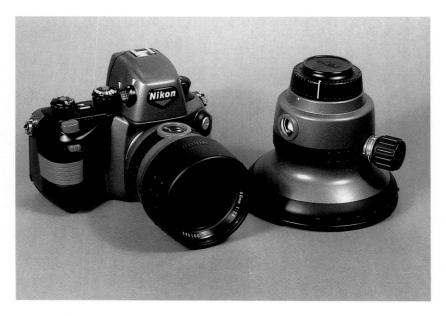

The R-UW Zoom Nikkor 20-35mm f2.8 lens (left) and the R-UW AF Micro-Nikkor 50mm f2.8 lens (on camera) are the two most versatile of the four Nikonos RS lenses.

R-UW AF Nikkor 28mm f2.8 Lens

The 28mm lens is the least expensive of the four RS lenses and does the least. The 1.6 reproduction ratio of the RS 28mm lens is the same as that produced by a Nikonos V close-up outfit and the 28mm lens. Thus, you can easily switch from moderately wide-angle diver portraits to close-ups. All you need to do for close-up photography is move in close to the minimum focused distance of ten inches.

● ● ●

The main problem with the 28mm lens, in my opinion, is that users will try to use the 28mm lens to photograph large subjects that require a 20mm lens. Because of the increased camera-to-subject distances required, the images won't be as sharp or colorful.

● ● ●

R-UW AF Zoom-Nikkor 20-35mm F2.8 Lens

The 20-35 mm zoom lens is the most versatile lens of the four Although marked for focal lengths of 35mm, 28mm, 24mm and 20mm on the zoom control knob, it can be set for any focal length between 20 and 35mm. You operate the large zoom control knob with your left hand, leaving the right hand free to operate the shutter release.

● ● ●
> *To get the most from this lens, use the widest possible zoom setting and get as close to your subjects as possible. Getting closer means better sharpness, color and details. Don't make the "Jim Church mistake" of forgetting that you have a zoom control.*
● ● ●

For wide-angle close-ups, it can be focused down to 1.2 feet, for a 1:10 reproduction ratio in the 35mm zoom position. This produces a picture area of almost 10 x 15 inches (24 x 360mm).

R-UW 13mm F2.8 AF Fisheye Lens

The ultra-wide, special-purpose 13mm fisheye lens is for photographers who want a lens wider than the RS 20-35mm

The zoom control knob of the 20-35mm lens is marked for 20mm, 24mm, 28mm or 35mm, but can be set between these markings.

The compact 13mm lens is a special-purpose ultra wide-angle lens that allows you to photograph large subjects at close distances. To keep your strobe from showing up in the upper corner of the picture, hold the strobe above the camera. Photo courtesy of Nikon, Inc.

zoom lens or the Nikonos V 15mm lens. Its 170-degree diagonal underwater picture angle allows you to photograph large subjects at close-distances. Also, its six-inch minimum focus allows you to take wide-angle close-ups. Although called a "fisheye" lens, it produces a rectangular picture that fills the 35mm slide or negative. Some earlier non-Nikon fisheye lenses produced a circular picture area in the center of a 35mm slide or negative.

WIDE-ANGLE VIEWFINDING

All of the RS lenses offer SLR (single-lens reflex) viewfinding. When you look through the Nikonos RS viewfinder, you are actually looking at your subject through the camera lens. You can use all of the automated focus and exposure controls, and still see the viewfinder displays. Accurate viewfinding requires

practice. For best results, follow these steps:

1. Get as close as possible to your subject.
2. Compose while looking through the viewfinder.
3. Look at the entire picture area, from corner to corner.
4. Fill the viewfinder with the subject, from edge to edge. Note: There will be slightly more in the picture than you see in the viewfinder.

The most common beginner's mistake is to compose wide-angle pictures by eye while peeking over the top of the viewfinder, then raising the camera and using the viewfinder as a "gunsight" to aim the camera. The results are pictures taken from to far away.

• • •

Ignoring details in the corners (heads, fins, etc.) is a major problem. Don't become so engrossed with what you see in the center of the viewfinder that you ignore distractions in the corners.

• • •

Move in close and fill the viewfinder with the subject. Also, don't choose subjects that are too small for your lens. A three-inch fish photographed three feet away, for example, will be only a dot in a wide-angle picture.

R-UW AF MICRO-NIKKOR 50MM F2.8 LENS

Say goodbye to extension tubes and close-up lenses, and all their assorted parts. Say goodbye to being "locked in" to one close-up or macro mode. The 50mm lens focuses from infinity down to 0.55 foot for a 1:1 (lifesize on film) reproduction ratio. Thus, the 50mm lens is excellent for close-up shots of almost any size close-up subject, from large eel faces to flamingo tongues.

• • •

The 50mm lens focusing scale shows reproduction ratios from 1:1 to 1:10. Thus, for scientific photography that requires comparative picture areas, you can preset for a preselected reproduction ratio. When shooting extreme close-ups at 1:1, be careful that you don't jam the lens port into coral.

• • •

All of the Nikonos RS lenses have a distance scale window on top of the lens casing, but they don't have depth of field scales.

The 50mm lens, when used with C (continuous servo autofocus), is an excellent lens for photographing fish. You can track a queen angel as it approaches and every shot will be in perfect focus.

DISADVANTAGES OF RS LENSES

Unfortunately, nothing is perfect, even an RS lens. In my opinion, the disadvantages are:

1. None of the lenses has a depth-of-field scale, nor can you preview depth of field as you would with a topside SLR camera.
2. While the choice of focal lengths ranges from 13mm to 50mm is broad, some underwater photographers want a 105mm lens for fish close-ups. At present, this requires a housed camera.

··· *19* ···

How To Focus
The Nikonos RS

*This is a "hands on" chapter. Please get your camera
and practice the focusing steps described as you read the
text. It's better to learn step-by-step topside than to suffer
frustration underwater.*

The Focus Mode Selector

Locate the focus mode selector on your camera body. The
meanings of C, S, P and F are as follows:

C (continuous servo autofocus). The autofocus predicts
the positions of moving subjects and adjusts the focus of the lens
to track the moving subject.

S (single servo autofocus). The autofocus focuses the lens
when the shutter release is pressed down halfway.

Single servo focus lock (subordinate to S). Not a separate
setting on the focusing mode selector dial, the focus lock keeps
the focus setting "locked in" as long as you keep the shutter
release partially depressed. This allows you to focus *selectively* for
any part of the subject.

P (power manual focus). Focus is manually controlled by
the power manual focus control (a lever/switch) in front of the
shutter release. You watch the image sharpen in the viewfinder
as you move the control. The further you move the control, the
faster the change in focus.

F (freeze-frame focus). F is a focus-priority mode. When a subject appears at a pre-selected distance, the camera shutter is automatically triggered. This mode is best for sneaking up on skittish or slowly moving subjects.

THE FOCUSING DISPLAYS

The focusing displays are shown at the left side of the display panel in the camera viewfinder:

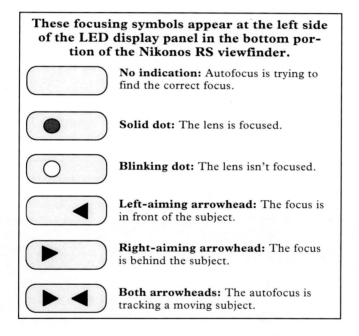

These focusing symbols appear at the left side of the LED display panel in the bottom portion of the Nikonos RS viewfinder.

No indication: Autofocus is trying to find the correct focus.

Solid dot: The lens is focused.

Blinking dot: The lens isn't focused.

Left-aiming arrowhead: The focus is in front of the subject.

Right-aiming arrowhead: The focus is behind the subject.

Both arrowheads: The autofocus is tracking a moving subject.

THE FOCUSING BRACKETS

Look into the viewfinder and locate the two focusing bracket markings in the center of the circle. A contrasty part of the subject must be within these brackets when you use C, S or F. With P, it doesn't matter what is in the focusing brackets because you are setting the focus manually.

HOW TO PRACTICE FOCUSING

Place several objects on a table, and sit down with camera in hand. Rest your elbows on the table and practice focusing on the different objects. The 50mm lens is the easiest to practice with because it will focus from a few inches to infinity in air, and changes in focus are easier to see. The 28mm and 20-35mm zoom lenses only focus from about one foot to three or four feet in air (because of the dome ports). The wider the angle of the 20-35mm zoom setting, the harder it is to see changes in focus in the viewfinder. To determine if the lens is focusing, listen for the sound of the small focusing motor.

● ● ● ──────────────────────────────

When looking at the viewfinder displays during the following practice drills, look only for image sharpness and the focusing symbols. Ignore all other displays.

────────────────────────────── ● ● ●

Use S (single servo autofocus) for stationary subjects, such as this starfish. Press the shutter release halfway down to focus. Push it all the way down to take the picture.

SITUATION
STATIONARY SUBJECTS

The goal is to focus on a stationary subject. Use S (single servo autofocus) mode. The lens automatically focuses when you press the shutter release halfway.

1. Set the focus mode selector for S.
2. Look into the viewfinder and aim the camera at the subject.
3. Press the shutter release down halfway.
4. Watch the image in the viewfinder sharpen.
5. When the *solid dot* appears, the lens is properly focused. You can trigger the shutter by depressing the shutter release all the way down.

● ● ● ——————————————————————————

A blinking dot tells you the camera can't autofocus. This is usually because the subject area within the focus brackets lacks contrast. You can't trigger the shutter when the dot is blinking. If you don't see any dot, the camera is still searching for the correct focus.

——————————————————————————— ● ● ●

SITUATION
SELECTIVE FOCUS,
STATIONARY SUBJECTS

The goal is selective focus. Selective focus means that you select which part of the subject you want to focus on. Then, you can shift the camera to improve composition without changing the focus. As long as you keep the shutter release halfway depressed (in the S mode), the focused distance is locked.

1. Aim the camera at your subject and press the shutter release down halfway.
2. When the *solid dot* appears, keep the shutter release depressed and shift your aim to change the composition.

3. Notice that the *solid dot* remains on. Depress the shutter release all the way and trigger the shutter.

• • •
Imagine that you are photographing an eel. You wish to focus on the eel's eye, but his eye isn't in the center of the picture (in view of the focusing brackets). You can selectively focus for the eye, hold the shutter release partway down for auto lock, and then change the camera angle and take the picture.
• • •

SITUATION
CENTER OF PICTURE AREA IS MIDWATER

The goal is to maintain focus. Imagine that you are underwater. You are photographing two divers: One diver is left of center, the other is right of center. There is nothing but midwater background in the center, where the focusing brackets will be when the picture is taken. To focus for the distance to the divers, and not on distant background the procedure is as follows:

1. Set the focus mode selector for S.
2. Center one of the divers in the viewfinder, within the focusing brackets.
3. Depress the shutter release button halfway to focus.
4. When you see the *solid dot*, keep the shutter release button depressed halfway as you shift the camera to recompose your picture.
5. When the picture is composed, press the shutter release button all the way down to take the picture.

• • •
If you don't wish to focus on the center of the picture, you can selectively focus for any part of the subject. Once the solid dot appears, you can lock the focus by holding the shutter release button down halfway. You can now shift the camera to compose the picture without the focus changing.
• • •

Mike Mesgleski used single servo focus lock for this photograph. He focused on the eye of one eel, kept the shutter release depressed halfway as he composed the picture, and then depressed the shutter release all the way to take the picture.

SITUATION
MOVING SUBJECT

The goal is to track a moving subject. C (continuous servo autofocus) tracks moving subjects, such as a graceful angel fish gliding by. As long as you keep the shutter release button depressed halfway, the camera keeps changing focus as the fish moves. The focus isn't locked; the shutter can be triggered at any time. The focusing steps are as follows:

1. Set the focus mode indicator for C.
2. Aim the camera so the moving subject is "seen" by the focusing brackets.
3. Keep the shutter release depressed halfway as you follow the moving subjects.

4. As long as you see either the *solid dot or two arrowheads* (facing each other in the viewfinder, the subject should be in proper focus. You can take the picture.

Note: The focus tracking indicator (two arrowheads) shows that the camera is predicting the distance to the moving subject. Although focus may not be totally accurate, it should be close.

● ● ● ──

A contrasty part of the subject must be within the focusing brackets. If the focusing brackets see a midwater or sand bottom background, focus can be lost. Because the shutter can be triggered at any time to take a picture, some pictures may be out of focus.

── ● ● ●

I used single servo focus lock to focus on the near videographer. Then, keeping the shutter release depressed halfway, I recomposed the picture and depressed the shutter release all the way to take the picture.

Use C (continuous servo autofocus) for moving subjects, such as swimming turtles. Hold the shutter release halfway down, and when you see two facing arrowheads (lower left of view-finder), take the picture.

SITUATION
LOW-CONTRAST OR DARK CONDITIONS

The goal is to focus in dim light. Use P (power manual focus) when you can't autofocus because of lack of contrast.

1. Set the focus mode switch to P.
2. Place your right index finger on the power manual focus control, just forward of the shutter release.
3. Moving the focus control to the left increases focused distance.
4. Moving the focus control to the right decreases focused distance.
5. Adjust the focus control until you see the *solid dot.*
Note: You can take a picture at any time, even if the lens isn't properly focused.

●●●

Remember: A left-aiming arrowhead means you are focused in front of the subject; a right-aiming arrowhead means you are focused behind the subject. You want to see a solid dot, but may have to estimate by working between alternating left-aiming and right-aiming arrowheads.

●●●

Manta rays at night are a difficult target for autofocus. Preset the focus for the desired distance with P (power manual focus). When the ray is at that distance, take the picture.

I preset with F and slowly moved in on this skittish little fish. When I reached the preselected distance, the shutter triggered automatically.

Dark conditions. If it's too dark to focus with the focusing brackets and solid in-focus dot (as described above), proceed as follows:

1. Estimate camera-to-subject distance by eye.
2. Operate the power focus control until you see the estimated distance in the distance scale window of the lens.
3. Take the picture.

SITUATION
Pre-Selected Distance

The goal is to have the shutter release automatically at a pre-selected distance. Imagine that a fish is resting on coral. It will swim away if you move suddenly or move in too close. You can preset the focused distance and slowly move the camera toward the fish. When you reach the preset distance, whamo—you get the picture. However if you or the fish move too fast, freeze-frame focus may not work. The procedure is easy:

1. Set the focus mode selector switch to P.
2. Use the power manual focus control to preset for the desired focused distance.
3. You can see the focused distance in the distance scale window.
4. Aim the camera at the subject. Depress the shutter release button and *hold it down.*
5. When the subject appears at the correct focused distance, the shutter will automatically release.

● ● ● ───────────────────────────

After each shot, take your finger off the shutter release button, then hold it down again for the next shot. The F (focus-priority mode) releases the shutter automatically when the subject is at the focused distance. For table-top practice, prefocus on a close subject. Then, lean back and forth to vary the camera-to-subject distance. This will give you an idea as to how fast the movement can be.

─────────────────────────── ● ● ●

··· *20* ···

How To Take Nikonos RS Sunlight Exposures

When you shoot a wide-angle scenic shot, you are really shooting a sunlight picture. The strobe is only a secondary light source which enhances colors and details in the foreground.

I strongly recommend that you shoot your first roll of film with sunlight only. Your first goal should be to learn how to use the focus modes and metering system. After you can operate the camera and lens quickly, add the strobe. Trying to do too much at first only complicates the learning process and can lead to frustration.

Sunlight Subjects

Choose subjects that depend on forms, shapes and contrast for good composition, not colors and details. Try shooting the following:

1. Upward views of the boat overhead with divers descending.
2. Upward silhouettes of divers, corals or wreckage.
3. Upward shots with sunbeams. For best results, use A (automatic). Select an aperture that requires a shutter speed of at least 1/250. The high shutter speed will sharpen the shimmering sunbeams in your pictures.

Divers silhouetted against the overhead sun are excellent subjects for sunlight exposures.

● ● ●

Avoid shooting down into dark areas or under ledges. Remember: Forms, shapes and contrast are the keys to good sunlight pictures.

● ● ●

What Is "A" (Auto)

When you set the shutter speed dial for A (auto), you have selected *aperture-priority automatic exposure control.* You select the aperture (f-stop), and the camera selects the shutter speed. The camera also automatically selects *matrix metering.*

What Is Matrix Metering

Matrix metering is the five-section pattern that the camera's built-in exposure meter reads. The meter reads each of the five

sections, analyzes the exposure differences and selects the shutter speed that the automatic exposure control system "thinks" is correct for the f-stop you selected.

MATRIX METERING PATTERN

For simplicity, assume that the exposure meter reads and averages the five sections shown in the diagram at left. It isn't a true average, but it gets the idea across.

"A" (AUTO) VIEWFINDER DISPLAYS

When you look into the camera viewfinder, you will see (from left-to-right):

- The focusing dot.
- The letter "A" which indicates that you are in the A (auto) mode.
- The shutter speed that the camera automatically selected.
- The f-stop that you selected.

In the following example, the viewfinder display indicates that the camera is set for A, and the camera selected 1/125 when you selected f5.6. As you select different f-stops with the aperture control dial, the camera automatically selects different shutter speeds.

● A 125 F 5.6

When to Use "A" (Auto)

A (auto) is best when the scene has a wide brightness range. For example, the scene may have bright surface in the background, lava tube walls at the sides, light sand at the bottom and a silhouetted diver near the center. The surface might call for f22, the lava tube walls for f2.8, the sand f5.6 and the diver f8. The matrix metering analyzes the five zones and selects the optimum exposure.

SITUATION
Sunlight,
Wide Brightness Range,
"A" (Auto)

The goal is a correct sunlight exposure. Wide-angle sunlight pictures sometimes have a wide brightness range—from dark subject areas to bright subject areas. A (auto) with its matrix metering is often your best choice.

1. Set the shutter speed dial for A.
2. Set the focus mode for S or C, as desired.
3. Aim the camera at the scene and depress the shutter release halfway.
4. Adjust the aperture control until you see the combination of f-stop and shutter speed that you want.
5. If the overexposure or underexposure analog display appears, adjust the aperture until it disappears.
6. Focus and take the picture.
7. To bracket exposures in the A mode, use the exposure compensation dial to bracket in one-third stop increments.

SITUATION
Fast Action, "A" (Auto)

The goal is to stop fast action. The seals are darting by. You

don't have time for S (single-servo focusing) or to use manual exposure control.

1. Set the focus control mode for C.
2. Set the shutter speed dial for A.
3. Aim the camera in the general direction of the subject.
4. Adjust the aperture dial until you see an acceptable shutter speed in the viewfinder display.
5. Aim, focus and take the picture.
6. If the autofocus won't track the moving subject, reset the focus mode control for P. Manually adjust focus for the distance at which you will will take your pictures.

MANUAL EXPOSURE MODE (CENTER-WEIGHTED METERING)

When you set the shutter speed dial for a specific shutter speed, such as 1/60 or 1/125, you have selected the *manual exposure mode*. You select both the shutter speed and the f-stop. The metering system automatically switches to a center-weighted metering pattern. *Seventy-five percent of the meter's sensitivity is within the circle you see in the viewfinder..*

MANUAL EXPOSURE VIEWFINDER DISPLAYS

When you look into the camera viewfinder, you will see (from left-to-right):

- The focusing dot.
- The letter "M" which indicates that you are in the

When I looked up at the silhouette of the coral, backlit with a ball of sunlight, I had one thought: the wide brightness range of this scene would be a good test for A (auto) with matrix metering. Matrix metering did a good job.

manual mode.
- The shutter speed that you selected.
- The f-stop that you selected.
- The analog display.

In the following example, the viewfinder display indicates that the camera is set for M, and that you selected 1/125 and f5.6, which is the correct exposure.

◉M 125 F 5.6 +2··1··0··1··2-

The *electronic analog display* appears at the right of the display panel in the bottom of the viewfinder. Adjust the aperture until the display indicates zero (the correct exposure).

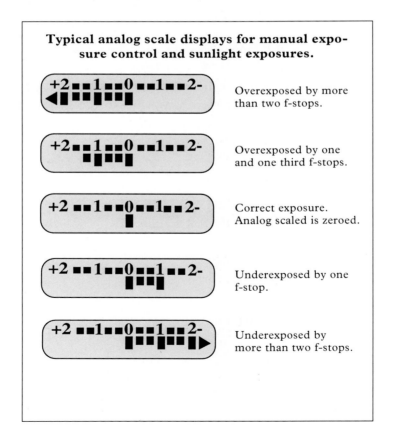

Typical analog scale displays for manual exposure control and sunlight exposures.

+2 ■ ■1 ■ ■0 ■ ■1 ■ ■2-

Overexposed by more than two f-stops.

+2 ■ ■1 ■ ■0 ■ ■1 ■ ■2-

Overexposed by one and one third f-stops.

+2 ■ ■1 ■ ■0 ■ ■1 ■ ■2-

Correct exposure. Analog scaled is zeroed.

+2 ■ ■1 ■ ■0 ■ ■1 ■ ■2-

Underexposed by one f-stop.

+2 ■ ■1 ■ ■0 ■ ■1 ■ ■2-

Underexposed by more than two f-stops.

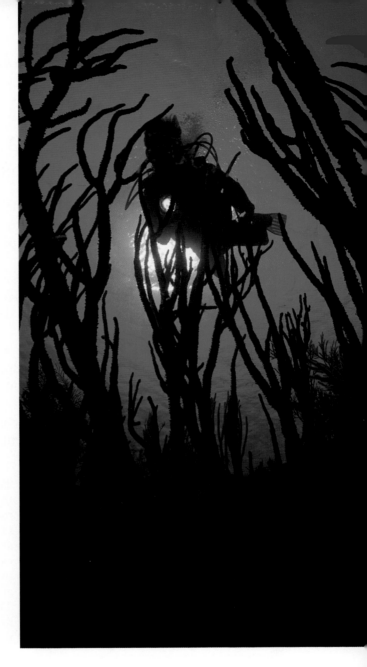

The diver was moving, so I didn't have time for a manual exposure-control adjustment. I set the shutter speed dial for A (auto) and looked into the viewfinder. The shutter speed of 1/90 (in the viewfinder display) was satisfactory, so I took the picture.

The main advantage of manual exposure is that you have more control over the exposure. You can aim the center-weighted metering system at any part of the scene. The disadvantage is that if the scene contains several large bright and dark areas, center-weighted metering can lead to incorrect exposure.

SITUATION
SUNLIGHT,
AVERAGE BRIGHTNESS RANGE,
MANUAL EXPOSURE CONTROL

The goal is a correct manual exposure. Manual exposure control is best when a subject of average reflectance (not too bright or too dark) fills the center of the picture area.

1. Set the shutter speed dial for the desired shutter speed.
2. Set the focus control for S or C as desired.
3. Aim the camera at the subject and depress the shutter release halfway.
4. Look for the analog exposure indicator in the viewfinder.
5. Adjust the aperture dial until the analog exposure indicator is at zero. This is the correct exposure.
6. Focus and take the picture.
7. You can bracket with the aperture control. The analog exposure indicator will show the extent of the bracketing.

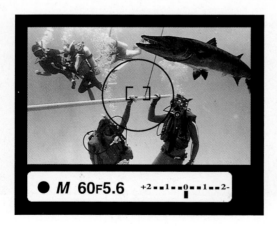

The solid dot shows that the lens is focused for the diver's hand on the safety bar. The display also shows that the exposure control is in the "M" manual mode at 1/60 second and f5.6. The analog exposure display is zeroed which indicates a correct exposure.

Because I wanted to set the f-stop for the blue water in the center of the picture, I set the shutter speed dial for 1/125 second. This put the automatic exposure control in the center-weighted mode.

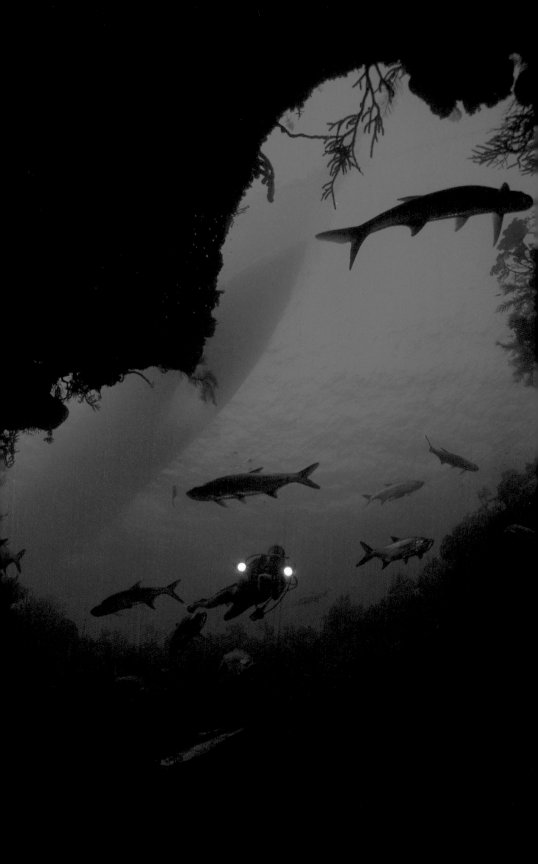

··· *21* ···

MAKING FRIENDS WITH THE NIKON SB-104

The Nikon SB-104 Speedlight (strobe, or flash unit) is so new, it deserves a chapter by itself. Although it can be used with the Nikonos V, it was designed for use with the Nikonos RS.

ON/OFF SWITCH WARNING

No, your strobe isn't broken. You must turn the ON/OFF switch to the OFF position before changing the function selector switch to STANDARD, CAMERA SLAVE or FLASH SLAVE. If the on/off switch is ON, you can't move the function selector.

THE BATTERY SYSTEM

The removable, rechargeable nicad battery pack is a definite improvement over the battery systems of the SB-102 and SB-103. It provides up to 120 full-power flashes with a three-second recycle time. The charging unit can recharge one battery pack in two hours, and two battery packs in four hours. Note: As of this writing the charger doesn't shut off automatically when the battery pack is fully charged.

STANDBY SWITCH

When the on/off switch and the standby switch are both turned

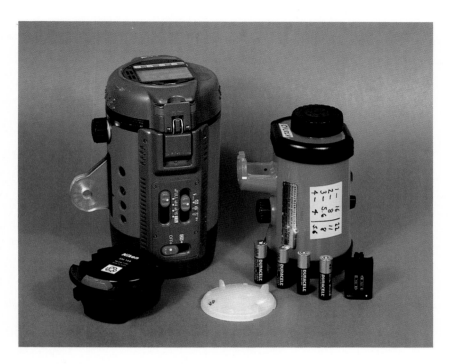

The SB-104 and battery pack (left) are significantly larger than the SB-103 and its battery pack of four AA cells (right). The SB-103 optional diffuser (center) widens the SB-103's beam to cover the picture area of a 15mm lens. Without the diffuser, the SB-103 beam covers a 28mm lens. Because the SB-104 has an underwater beam angle of 100 degrees, which more than covers a 15mm lens, a wide-angle diffuser isn't provided.

ON, the SB-104 is turned off after about 80 seconds. To turn the SB-104 on again, simply press the shutter release button partway down. Turning the on/off switch to OFF and then to ON also turns the SB-104 back on.

CONNECTOR (SYNC) CORDS

Single and double connector cords are available for connecting one or two strobes to the Nikonos RS. A special cord with a detachable connector allows you to attach or detach cords underwater. (These cords can also be used with the Nikonos V.)

A special remote cord is available for the Nikonos RS. It attaches to the remote socket at the upper left of the camera body, and can be used to trigger a tripod-mounted camera from a distance.

SITUATION
USING SLAVE FLASH

The goal is to take a picture of another diver with his strobe flashing. His strobe is set for slave flash. Your strobe is the master strobe that triggers the model's slave strobe. If your model is facing you, or if the model's strobe is aimed at a close subject, set the model's strobe for 1/16 power. Because the model's slave

The detachable cord has a fitting (top of the picture) that can be attached or detached underwater. This cord can also be used with the Nikonos V. Photo courtesy of Nikon, Inc.

The remote cord connector screws into the remote socket of the camera body. You press the red button on the handle to trigger the shutter. Photo courtesy of Nikon, Inc.

strobe can overexpose in your picture, bracket the slave strobe's power settings at 1/4 and 1/16 power.

1. Set the model's SB-104 function switch to FLASH SLAVE (broken arrow symbol).
2. Set the model's flash mode indicator to a manual power setting (usually 1/4 or 1/16 power).
3. When the slave sensor of the model's SB-104 detects the flash from your strobe, it triggers a flash.

●●● ────────────────────────────────

The SB-104 standby setting doesn't work in the slave flash mode. The electricity needed to power full-power flash is consumed every 10 minutes that the strobe is ON in the slave flash mode.

──────────────────────────────── ●●●

SITUATION
USING CAMERA SLAVE FLASH

The goal is to take a picture without touching the camera. You can mount the camera on a tripod and leave it waiting for an elusive fish to position itself. You trigger the camera slave flash by flashing another strobe from a distance. When the SB-104 detects the flash of this second strobe, it flashes and the Nikonos RS takes a picture. The range of the SB-104 sensor (two strobes facing each other) can exceed 30 feet.

1. Turn the SB-104 power switch OFF (so you can move the function selector).
2. Set the function selector of the SB-104 to CORDLESS REMOTE (the camera symbol to the right).
3. Set the camera focus selector switch to P (power focus) and preset focus.
4. Set for A (auto) or M (manual) exposure mode.
5. Turn the SB-104 power switch ON.
6. The SB-104 will flash, and a picture will be taken each time the slave sensor detects the flash of another strobe.

●●● ─────────────────────────────────

When the SB-104 standby switch is set for ON, the amount of electricity needed for one full-power flash is lost every six hours. When the standby switch is set for OFF, and on/off switch is in the ON position, the power for a full-power flash is lost every 10 minutes.

───────────────────────────────── ●●●

SITUATION
USING THE SIGNAL FLASH

The goal is to save your rear. It's getting dark, and you're drifting out to sea. Oh golly, it's time to use the signal flash to summon help!

1. Turn the SB-104 power switch ON.

The SB-104 control panel is located on the right side of the strobe body casing.

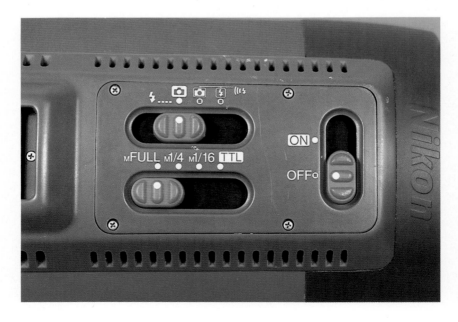

2. Slide the function selector to the CROOKED ARROW-HEAD (test flash position) and hold it in place for about four seconds. The SB-104 will now flash at 1/32 power about every two seconds.
3. A fully charged battery will power up to about 3,000 flashes in one and one-half hours.

SITUATION
REAR CURTAIN FLASH SYNC

The goal is to use a slow shutter speed to show the subject's movements. You do this with the rear curtain flash sync. The strobe flashes at the closing of the shutter.

1. Topside, open the camera back and set the sync mode switch to REAR.
2. Set the SB-104 function selector to STANDARD.
3. Set the flash mode to TTL or any manual position.
4. Set camera shutter speed dial to A (automatic) or M (manual).
6. Set focus with the desired mode.
7. Take the picture.

● ● ● ─────────────────────────────────────

If you set for A (auto), the shutter speed can vary from one second to 1/125 second. For slower shutter speeds, set for B (bulb) and the shutter remains open as long as the shutter release button is depressed.

─────────────────────────────────── ● ● ●

NIKON STROBE COMPARISON CHART

The SB-102 and SB-103, as well as the SB-104, can be used with the Nikonos RS for manual, TTL or matrix flash fill. However, only the SB-104 features camera slave flash, the battery-saving standby switch and the signal flash. A summary chart of these three strobes follows.

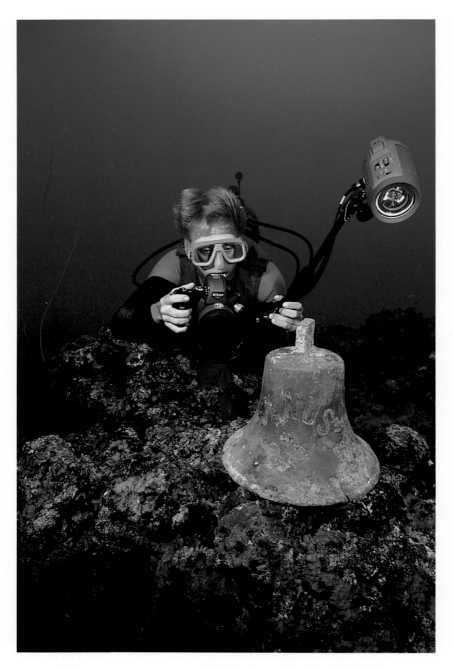

Kevin Davidson prepares to photograph a ship's bell with a Nikonos RS, 20-35mm zoom lens and SB-104 strobe.

NIKON STROBE COMPARISON CHART			
Feature	**SB-102**	**SB-103**	**SB-104**
Alkaline or Nicad cells	Yes	Yes	No
Beam coverage	28mm	28mm	15mm
Beam with diffuser	15mm	15mm	--
Camera slave flash	No	No	Yes
Diameter (inches)	5.5	3.75	4.9
Electrical alert	No	No	Yes
Full, 1/4 and 1/16 power	Yes	Yes	Yes
Heat alert	No	No	Yes
ISO 100 Guide Number	24	33	33
ISO 100 U/W Guide Number*	22	35	35
Length (inches)	8.25	6.75	8.7
Matrix flash fill with RS	Yes	Yes	Yes
Modeling light	Yes	No	No
Moisture alert	No	No	Yes
Nicad battery pack	No	No	Yes
Number of flashes with Nicads	60-65	75-100	120
Recycle time with Nicads	4-6 sec.	4-6 sec.	3 sec.
Signal flash	No	No	Yes
Slave mode	Yes	No	Yes
Test flash switch	Yes	No	Yes
TTL capability	Yes	Yes	Yes
Weight in air (lbs.)**	3.7	1.7	4.4

Underwater Guide Numbers are the author's estimates and are lower than those specified by Nikon. This is because I use angled lighting, often handheld. The numbers are for full-power flash, without diffusers for the SB-102 or SB-103.
**Weights are for the flash head only. Baseplates and arms add additional weight.*

··· *22* ···

How To Take
Nikonos RS Manual
Strobe Exposures

This is a "spare tire" chapter. Let's assume (heaven forbid) that your strobe flunked the TTL test (see Chapter 6). All isn't lost—you can still use a TTL strobe in the manual mode. We will be thinking of distances of two apparent feet and farther in this chapter. Closer distances are covered in Chapter 23.

Your Exposure Table

Y ou can use the detachable *aperture scale charts* included with the SB-104. However, if you handhold the strobe or use long strobe arms for angled lighting, more exposure is usually needed. If so, use the ISO charts as follows:

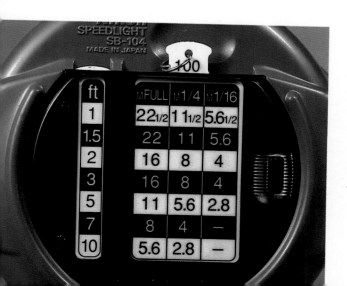

A set of removable exposure guides can be attached to the rear of the SB-104. Separate guides are provided for ISO 25, 50/64, 100, 200, 400 and 800/1000.

ft	M FULL	M 1/4	M 1/16
1	22 1/2	1 1 1/2	5.6 1/2
1.5	22	11	5.6
2	16	8	4
3	16	8	4
5	11	5.6	2.8
7	8	4	–
10	5.6	2.8	–

SPEEDLIGHT
SB-104
MADE IN JAPAN

100

- Use the ISO 25 chart for ISO 50 or 64 film.
- Use the ISO 50/64 chart for for ISO 100 film.
- Use the ISO 100 chart for ISO 200 film.
- Use the ISO 200 chart for ISO 400 film.

For other strobes, use *The Secret Exposure Chart* (Chapter 5) to make your exposure table. You can use plastic tape and a laundry marker to attach your exposure table to the side of the strobe or to the back of the camera body.

To Avoid Confusion

In this chapter the term "manual exposure control" applies to both the camera and the strobe. In each situation, you will manually set a shutter speed and use a manual (non-TTL) strobe power setting. Remember: The Nikonos RS will synchronize with any strobe at shutter speeds of 1/125 or slower.

SITUATION
Sunlight with Strobe, What F-Stop (Wipe to the Right)

The goal is to set the f-stop for the stronger light source, sunlight or strobe. If sunlight is the stronger light source, the f-stop will be for the sunlight exposure. If strobe light is the stronger light source, the f-stop will be for the strobe exposure.

1. Set the SB-104 function selector for STANDARD.
2. Set the SB-104 flash mode selector for M FULL.
3. Set the shutter speed dial for for 1/60 or 1/125 second.
4. Set the aperture dial for the f-stop from the strobe exposure table.
5. Verify that the ready light is glowing.
6. Depress the shutter release halfway and look at the analog exposure scale.

7. If the scale indicates overexposure (any marks to the left of center), adjust the aperture to zero the scale. Focus and take the picture.
8. If the scale is at zero, close the aperture to show one or two marks to the right of zero. Focus and take the picture.
9. If the scale shows underexposure (any marks to the right of zero), focus and take the picture.

Because this is a "spare tire" chapter, we need to borrow some tools. Please refer to the viewfinder displays in the Situation: Sunlight with Strobe (What TTL F-Stop, Wipe to the Right) in Chapter 23.

I set the aperture for a manual exposure of f22 (from my strobe exposure table), and the shutter speed for 1/125 second. Although the analog exposure scale in the Nikonos RS viewfinder showed more than two f-stops of underexposure, the TTL strobe exposure was correct.

SITUATION
SUNLIGHT,
MANUAL EXPOSURE CONTROL AND STROBE FILL

The goal is a sunlight exposure with flash fill to brighten colors and details. You must be sure that the strobe exposure is at least one f-stop weaker than the sunlight exposure.

1. Set the shutter speed dial for 1/60 or 1/125 second.
2. Set the SB-104 function selector for STANDARD.
3. Set the SB-104 flash mode selector for M FULL.
4. Adjust the aperture for a sunlight exposure. (Zero the analog scale.)
5. Compare the f-stop in the viewfinder display with the f-stop on the strobe exposure table.
6. Select a power setting (or vary strobe-to-subject distance) for a strobe exposure one f-stop weaker (next lower-numbered f-stop) than the f-stop in the viewfinder display.
7. Verify that the ready light is glowing.
8. Focus and take the picture.
9. To bracket exposures, use the aperture dial to vary the f-stop.

SITUATION
BRIGHT SUNLIGHT,
MANUAL EXPOSURE CONTROL,
FAR AND NEAR SUBJECTS

The goal is a strobe exposure for a near subject and a sunlight exposure for the distant background. For example, suppose you have two subjects: a near sponge and a silhouetted diver in the background. Because you want the sunlight exposure in the background, sunlight will determine the aperture. You, however, must choose the correct strobe-to-subject distance or power setting for the strobe exposure on the near sponge.

I set the shutter speed for 1/60 and metered for the sunlight exposure for the two divers. The twin strobes were set for 1/14 power to add a touch of strobe fill to the foreground.

Begin with the sunlight exposure for the far subject:

1. Set the SB-104 function selector for STANDARD.
2. Set the shutter speed dial for 1/60 or 1/125 second.
3. Meter for the sunlight aperture. (Zero the analog scale.)
4. The f-stop you see in the viewfinder display is the f-stop you will use.

Determine the strobe exposure for the near subject:

5. See what f-stop is shown in the viewfinder display.
6 Look at the strobe exposure table—find the strobe-to-subject distance for that f-stop.
7. Choose a strobe-to-subject distance or power setting that equals the f-stop shown in the viewfinder.

Take the picture:

8. Verify that the ready light is glowing.
9. Aim the strobe at the near subject.
10. Focus and take the picture.

● ● ● ─────────────────────────────

In summary, you are metering and exposing for two separate subjects (the near and the far). The near is a close-up strobe exposure; the far is a sunlight exposure. To bracket the sunlight exposure, vary the aperture; to bracket the strobe exposure, vary the strobe-to-subject distance or the power setting.

───────────────────────────── ● ● ●

SITUATION
MANUAL EXPOSURE CONTROL,
IN THE DARK

The goal is to choose the correct f-stop. When you are photographing in dark conditions, the strobe will overpower sunlight. Use the f-stop from the strobe exposure table. *Ignore the analog display in the viewfinder.*

1. Set the SB-104 function selector for STANDARD.
2. Set the SB-104 flash mode selector for M FULL.
3. Set the shutter speed dial for 1/60 or 1/125 second.
4. Set for the aperture from the strobe exposure table.
5. Ignore the analog display.
6. Verify that the ready light is glowing.
7. Focus and take the picture.

● ● ● ─────────────────────────────

Close-up exposures taken at f16 and f22 usually have dark backgrounds. Exposures taken in dark conditions will also have dark backgrounds at wider apertures, such as f5.6.

───────────────────────────── ● ● ●

··· *23* ···

HOW TO USE
RS MATRIX
FLASH FILL AND TTL

Although this chapter is written for the RS camera body and Nikon SB-104 strobe, you can also use the SB-102, SB-103 and non-Nikon TTL strobes. We will be thinking of distances of two apparent feet and farther in this chapter. Closer distances are covered in Chapter 24.

IT'S REVIEW TIME

Before attacking this chapter, look back at Chapters 5-7 and 18-21. Otherwise, if you're a beginner, you could get lost. Also, remember that the Nikonos RS will synchronize with any strobe at shutter speeds up to 1/125, and the TTL can be used with ISO film speeds from 25 to 1,000.

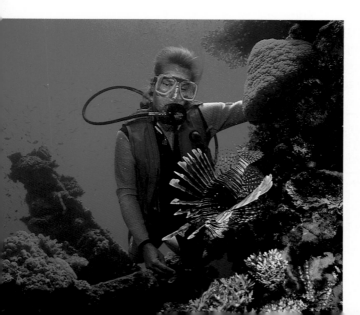

I set the Nikonos RS shutter speed dial for A (auto) and adjusted the aperture until f8 at 1/60 second appeared in the viewfinder display. The matrix flash fill from my SB-104 provided flash fill on Jeannie Wiseman and the lionfish.

To Avoid Confusion

As you read this chapter, you will probably be jumping back and forth between your RS and SB-104 manuals and this book. Therefore, I'll use Nikon's terminology. I will use "flash fill," instead of "strobe fill" in this chapter.

The terms, "A" (auto), and "manual exposure control." refer to the camera only. The strobe will always be set for TTL in this chapter.

What Is Matrix Flash Fill

Matrix flash fill is a major feature of the Nikonos RS, and is not a feature of the Nikonos V and previous models. Flash fill means adding strobe light to a sunlight picture to enhance colors and details. The matrix metering system analyzes the sunlight exposure for five segments of the picture area, and regulates the output of the TTL strobe for balanced flash fill in the foreground.

Matrix Metering Pattern

The matrix metering system analyzes the exposure values for each of the five segments (upper left, upper right, lower left, lower right, and center) of the scene. It then indicates the sunlight exposure in the viewfinder display and regulates the output of the strobe.

When To Use Matrix Flash Fill

Matrix flash fill can be used with any RS lens, at almost any distance. The flash fill adds soft lighting to the foregrounds of sunlight pictures. (I've also taken some interesting 50mm close-

ups with matrix flash fill.) The five-segment matrix metering pattern provides accurate sunlight exposures, and the flash fill has a natural appearance.

How to Use Matrix Flash Fill

Basically, you set the shutter speed dial for A (auto) and look into the camera viewfinder. Adjust the aperture until you see the desired f-stop and shutter speed combination (usually 1/60 or 1/125 second). When the shutter is released, the strobe delivers the correct amount of light for flash fill.

SITUATION
Sunlight Exposure, Matrix Flash Fill

The goal is a sunlight exposure with flash fill to enhance colors and details.

1. Set the SB-104 function selector for STANDARD.
2. Set the SB-104 flash mode selector for TTL.
3. Set the shutter speed dial for A.
4. Look into the viewfinder. Adjust the aperture until the desired f-stop and shutter speed appear. (The analog display shouldn't appear.)
5. Verify that the ready light is glowing.
6. Focus and take the picture.
7. If the strobe ready light blinks, don't worry. The result will be a sunlight exposure with weak flash fill.

If the analog display is visible in the viewfinder when you take the picture, *the exposure system switches to TTL.* The TTL exposure is based on subject area within the circle you see in the viewfinder.

- If the analog display indicates overexposure (plus side), the background and centered subject will be overexposed.
- If the analog display indicates underexposure (minus side), the background will be darkened and the centered subject will receive a TTL strobe exposure.

WHEN TO USE TTL

Use TTL when you want more strobe light to reach your subject than it would with matrix flash fill. When you choose TTL, set the shutter speed dial for a shutter speed (manual exposure control). At close and medium distances, your TTL subjects will be bright and colorful against dark backgrounds. To summarize, TTL provides stronger strobe lighting than matrix flash fill when you are within the TTL auto range.

● ● ● ──────────────────────────────────

The procedures given for the following RS TTL situations are often similar to the procedures for RS manual strobe control. Rather than try to combine manual and TTL, I have split these into two separate chapters to make the procedures easier to read and follow.

────────────────────────────────── ● ● ●

SITUATION
SUNLIGHT WITH STROBE
WHAT TTL F-STOP
(WIPE TO THE RIGHT)

The goal is to set the f-stop for the stronger light source, sunlight or strobe. If sunlight is the stronger light source, the f-stop will be for the sunlight exposure. If strobe light is the stronger light source, the f-stop will be for the strobe exposure.

1. Set the SB-104 function selector for STANDARD.
2. Set the SB-104 flash mode selector for TTL.

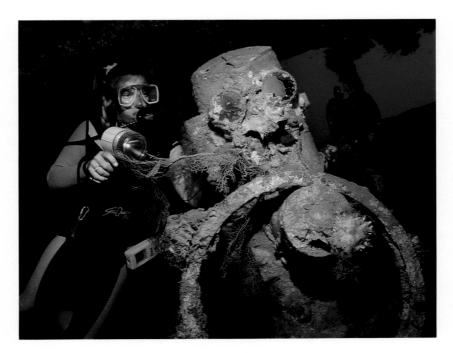

It was too dark inside the bridge of the Nippo Maru *for matrix flash fill. I used the f-stop from the strobe exposure table, set the shutter speed for 1/125 second and ignored the underexposure warning of the analog exposure scale. The SB-104 TTL exposure made Jeannie Wiseman and the binnacle of the* Nippo Maru *stand out against the dark background.*

3. Set the shutter speed dial for for 1/60 or 1/125 second.
4. Set the aperture dial for the f-stop from the strobe exposure table.
5. Verify that the ready light is glowing.
6. Depress the shutter release halfway and look at the analog exposure scale.
7. If the scale indicates overexposure (any marks to the left of center), adjust the aperture to zero the scale. Focus and take the picture.
8. If the scale is at zero, close the aperture to show one or two marks to the right of zero. Focus and take the picture.
9. If the scale shows underexposure (any marks to the right of zero), focus and take the picture.

Typical "wipe to the right" analog exposure displays. Starting with the displays shown at left, you adjust the aperture to achieve the displays shown on the right.

If you see any marks to the left of zero, sunlight is stronger than strobe light

Adjust aperture to zero the analog scale for a sunlight exposure with strobe fill.

Strobe and sun at about equal angles to subject and striking same subject areas.

Reduce exposure by 2/3 f-stop (two marks) to avoid overexposure.

Strobe at about 45 degrees to sun, or in deep water. Some overlap of light.

Reduce exposure by 1/3 f-stop (one mark) to avoid over exposure.

Strobe only illuminates shadow areas that don't receive direct sunlight.

No adjustment necessary. Sunlight and strobe light are balanced.

If you see any marks to the right of zero, strobe light is stronger than sunlight.

No adjustment necessary. The more marks displayed, the darker the background.

SITUATION
Darkening the Background,
What TTL F-Stop

The goal is choosing an f-stop that will darken the background. Some photographers wish to deliberately darken the midwater background to make near subjects appear sharper and brighter. For example, suppose you are photographing medium-sized fish at distances of about two or three feet with the 50mm lens. Underexposing the background one or more f-stops makes the fish appear bright and colorful against a dark blue background. The procedure I use is as follows:

1. Set the SB-104 function selector for STANDARD.
2. Set the SB-104 flash mode selector for TTL.
3. Set the shutter speed to 1/125 second.
4. Choose the aperture from the strobe table.
5. Verify that the ready light is glowing.
6. Aim at the fish and focus (continuous autofocus works with moving fish).
7. Ignore the underexposure warning in the viewfinder.

This system works great out to about three feet in clear Caribbean water. The 1/125 second shutter speed stops the fish's movement for a sharp picture, and the SB-104 strobe is usually strong enough to overpower sunlight at two or three feet. For the best exposure, the fish should fill the center picture area.

SITUATION
In the Dark,
What TTL F-Stop

The goal is to select the correct f-stop. Imagine that you are inside a sunken ship in Truk Lagoon, inside a cave or lava tube, or on a night dive. You won't use the sunlight metering system; the TTL strobe will be your only light source.

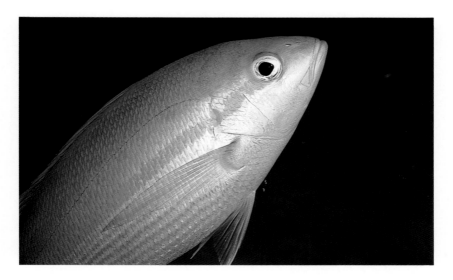

Because the fish was close to both the camera and the strobe, the f22 TTL strobe exposure darkened the midwater background.

Except for the beam of my small dive light, the rear wheel of this Japanese bicycle was shrouded in total darkness. I estimated camera-to-subject distance by eye, selected the aperture from my strobe exposure table and used P (power manual focus) for this TTL exposure. I had to take the photograph quickly because my bubbles were causing debris to rain down from overhead.

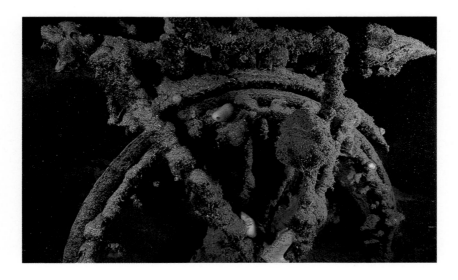

1. Set the SB-104 function selector for STANDARD.
2. Set the SB-104 flash mode selector for TTL.
3. Set the shutter speed for 1/60 or 1/125.
4. Use the strobe exposure table to determine aperture.
5. Focus (power manual focus will probably be required).
6. Ignore the analog underexposure warning in the viewfinder.
7. Verify that the ready light is glowing.
8. Focus and take the picture.
9. If the strobe ready light blinks to signal a full-power flash, open the aperture one-half f-stop and try again.

●●●

Because autofocus won't work in darkness, estimate camera-to-subject distance by eye. Then, use the power manual focus to set the focus for your estimate. The light in the distance scale window lets you see the focused distance.

●●●

··· *24* ···

HOW TO TAKE
NIKONOS RS
CLOSE-UPS AND MACRO

If you want bright colors and razor-sharp details, this chapter is for you. Wide-angle shots may set the stage, but close-ups showcase delicate marine life.

AVOIDING CONFUSION

The lens distance scale measures from the film plane (surface of the film) to the subject. Underwater, where your brain turns to mush, this can be confusing. For example, a fish appears to be about six apparent inches from the front of your lens, but the focus scale reads "one foot." To see for yourself in air, adjust the power manual focus of your 50mm lens for one foot and move in on a subject until it is sharply focused. The subject will appear to be about six inches from the front of the lens.

SHOOTING UP CLOSE

You can shoot close-ups with any of the RS lenses. The 28mm lens produces a minimum close-up picture area of almost 6 x 9 inches. The 20-35mm zoom lens produces a minimum close-up picture area of almost 10 x 15 inches. Both of these lenses are great for close-ups of fish, eels and other sealife that fits the picture area of the lens.

The 50mm lens is a fish photographer's delight. You can adjust distance to vary picture area as you compose. It is more

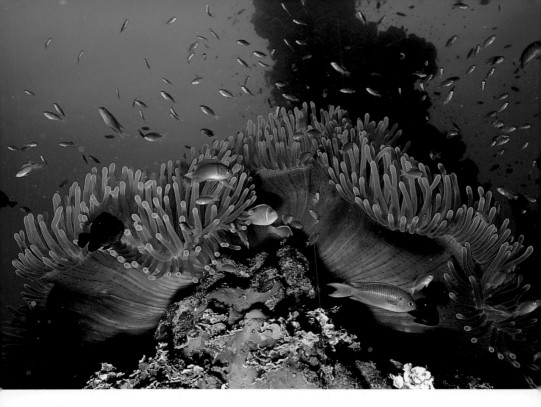

Randy McMillan used 1/60 second and f16 for the background exposure of this wide-angle close-up. He set his SB-104 strobe for TTL and aimed it upward to illuminate the underside of his subject.

versatile than the Nikonos close-up outfit or extension tubes used with the Nikonos V. You can vary distance and picture area, and even focus for a 1:1 image ratio. At 1:1, however, be careful that you don't bump the lens port against coral.

● ● ● ───────────────────────────

When you focus extremely close with the 50mm lens, you can see the image ratios (from 1:10 to 1:1) on the lens distance scale. In this range, the lens is focused for macro photography.

─────────────────────────── ● ● ●

MOUNTING THE STROBE

You can mount the strobe on the strobe arm and tilt it downward and inward so it intersects the subject, or you can handhold the strobe. When handholding, try holding the strobe

above the camera body so light spreads evenly over the picture area.

For macro photography (1:10 to 1:1) with a 50mm lens, I use two SB-103 strobes mounted to the left and right of the camera with adjustable Technical Lighting Control Macro Arms. The strobe-to-subject distances are usually less than one measured foot for extreme close-ups. For 1:1, the strobe distance is about six measured inches.

CLOSE-UP F-STOPS

For most close-ups, you can use your personal exposure table of f-stops for apparent strobe-to-subject distances. See Example 4, Chapter 5. However, when you are using the 50mm lens, the strobe must be as close as six inches when you focus for 1:1.

The simplest way to establish strobe-to-subject distances for close-ups or macro is to:

1. Begin with *The Secret Exposure Chart* (Chapter 5). Use it to find a starting point f-stop.
2. Watch the ready light in the viewfinder as you take test exposures.
3. Adjust the aperture until you find the point where the full-power flash signal flashes. Then, open the aperture a half stop (to the next lower-numbered f-stop).

Note: Closing the aperture one-half f-stop allows the TTL strobe a half stop of reserve power for dark subjects. You can also vary the strobe-to-subject distance if you don't wish to change the aperture.

WHERE TO FOCUS

Because close-up depth of field is so shallow, it is often best to focus past the closest part of your subject. This puts more of your subject within the depth of field zone. With fish, I always focus

for the eye, even if the nose is closer. The nose and tail can be slightly out of focus, but the eye must be sharp.

VIEWFINDING AND FOCUSING AT NIGHT

You will need a dive light to illuminate the subject for viewfinding and focusing at night. You can attach a small dive light to the strobe, or your dive buddy can illuminate subjects for you. Either way, the illumination from a dive or video light is too weak to affect your exposure.

• • • ─────────────────────────────────

Be careful when shooting close-ups with RS lenses. Although the lens ports are recessed and have rubber shades, you could accidentally bump the lens port against hard corals.

───────────────────────────────── • • •

SITUATION
SHOOTING WIDE-ANGLE
OR MACRO CLOSE-UPS
WITH TTL

The goal is a wide-angle or macro close-up picture with a TTL strobe exposure.

1. Mount the strobe on a macro arm, or tilt the strobe head to intersect at a close-up distance. With the SB-102 or SB-103, use the diffuser.
2. Set the SB-104 function selector for STANDARD.
3. Set the SB-104 flash mode selector for TTL.
4. Set the exposure compensation dial for one mark past zero (one-third f-stop underexposure).
5. Set the shutter speed to 1/125 second.
6. Choose the aperture from your personal strobe exposure table (Example 4, Chapter 5).
7. Verify that the ready light is glowing.

8. Center the subject and focus (use S for still subjects and C for moving subjects).
9. Ignore the analog display in the viewfinder.
10. If the ready light blinks for a full-power flash, open one-half f-stop and try again.

Fine Tuning TTL Exposures

TTL full-power flash signal. You can find the optimum combination of aperture and strobe distance by watching the strobe ready light. Vary the aperture or strobe distance until the

I focused on the lionfish's body rather than on the fins that extended toward me. Thus, most of the lionfish's body was within the depth of field (the narrow zone of sharpness).

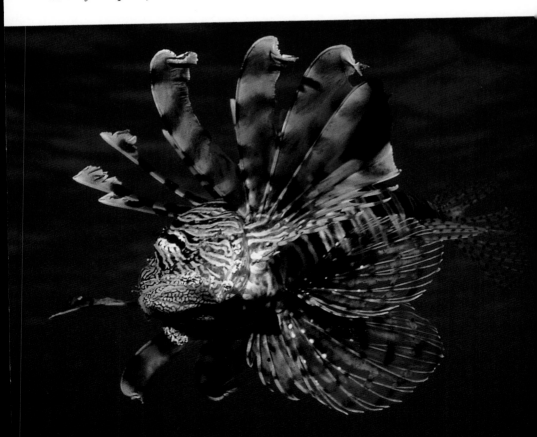

This squirrelfish was photographed with an RS 50mm lens and a TTL strobe exposure. The close-up f22 f-stop darkened the background. A manual exposure could have been used with identical results.

What would happen if you set the RS shutter speed dial for A (auto) and photographed the squirrelfish with an f5.6 sunlight exposure and matrix flash fill? The fish would remain bright and colorful, depth of field would be reduced (because of f5.6 sunlight f-stop) and the midwater background would be blue.

strobe ready light blinks to signal a full-power flash. Then, open the aperture one-half f-stop or reduce the strobe distance a few inches.

TTL exposure compensation. Set the exposure compensation dial for minus one mark (one-third f-stop) underexposure. *The purpose of this underexposure is to prevent small, bright subject areas from overexposing.*

TTL bracketing. You can bracket exposures with the exposure compensation dial. Minus marks and numbers decrease exposure. Plus marks and numbers increase exposure.

SITUATION
SHOOTING WIDE-ANGLE
OR MACRO CLOSE-UPS
WITH MANUAL EXPOSURE CONTROL

The goal is a wide-angle or macro close-up picture with a manual strobe exposure.

1. Mount the strobe on a macro arm, or tilt the strobe head to intersect at a close-up distance. With the SB-102 or SB-103, use the diffuser.
2. Set the SB-104 function selector for STANDARD.
3. Set the SB-104 flash mode selector for M FULL.
4. Set the exposure compensation dial for zero.
5. Set the shutter speed to 1/125 second.
6. Choose the aperture from your personal strobe exposure table (Example 4, Chapter 5).
7. Verify that the ready light is glowing.
8. Center the subject and focus (use S for still subjects and C for moving subjects).
9. Ignore the analog display in the viewfinder.
10. Bracket exposures by varying either the aperture or strobe distance.

SOLVING PROBLEMS

The two most common problems you will encounter will be forgetting to change the f-stop and the strobe angle each time you change camera-to-subject distance. At close distances, f-stop and strobe angle are critical! For reference underwater, tape the following list to the back of your camera and follow it (1, 2, 3 and 4) each time you take a picture.

1. F-stop
2. Strobe angle
3. Focus
4. Shoot

PART

··· 6 ···

MAINTAINING YOUR EQUIPMENT

··· *25* ···

MAINTAINING CAMERA BODIES

Please don't skip over this chapter; it could save you money. Years of experience with Nikonos cameras have taught me that those who overlook maintenance end up paying high repair bills.

WASHING AND SOAKING

During periods of frequent use, a quick rinse in fresh water between dives will suffice. As long as the hidden O-rings in the camera body remain wet, you don't have problems. It's drying out without proper washing that causes most damage—corrosion and salt crystals on hidden O-rings are the problem.

When you take the camera into the water again, problems arise. A salt crystal can unseat an O-ring seal for a brief moment before the crystal dissolves. If just a few droplets seep past the hidden O-rings of an ISO dial or rewind shaft, corrosion starts inside the camera body.

After the diving is over, soak the camera in warm, fresh water for at least an hour. (Remember to replace the flash socket plug.) Work all camera and lens controls and knobs. Rinsing under a running tap is great, but don't forget the soaking. Don't use an airhose to dry the camera. High-pressure air could blow water past an O-ring. (An O-ring needs sea pressure to make a watertight seal.)

CAMERA BODY MAINTENANCE

The basic steps for maintaining a camera body are listed below:

1. Clear a place to work.
2. Remove the main O-ring that seals the camera back.
3. Clean the O-ring and the groove in the camera back with a clean, lint-free cloth. Apply a thin coating of Nikonos O-ring grease to the O-ring and replace it.
4. Clean the inside of the camera body with an artist's brush.
5. Clean the lens mount insert; apply a thin coating of grease.
6. Clean and lubricate the battery compartment, lid and O-ring.
7. Clean and lubricate the flash socket, plug and O-ring.
8. Clean and lubricate the rewind crank (Nikonos V).
9. Test the camera battery.
10. Test the shutter speeds.
11. Test the automatic exposure system.

How often should you clean and maintain the camera body? There is no single answer. A clean camera can be used for several days of diving between cleanings. I always wash and clean the camera at the end of a dive trip. This way, it's ready for the next trip.

● ● ● ———————————————————————————

There are exceptions: Clean the camera anytime you see sand on the O-rings, or if the camera back feels stiff when you close it, or if the lens seems harder to rotate when you install it. This stiffness tells you the grease is dirty or has been rubbing off.

——————————————————————————— ● ● ●

I test the battery, shutter speeds and exposure accuracy before each trip, and several times during each trip. Camera batteries usually last about a year with infrequent use, and six months or less with heavy use.

Removing the Main O-Ring

Don't use metal tools or dental picks to remove the O-ring. If you gouge the metal sealing surface, you have big problems! Use

You can sometimes coax an O-ring out of its groove with the rounded edge of a plastic card.

finger pressure, or the edge of a plastic card to coax the O-ring out of its seat.

CLEANING THE O-RING GROOVE

Use the folded edge of a paper towel to clean out the O-ring groove. While my past writings said to use cotton swabs, I've changed to folded portions of paper towel. The towel is less likely to leave lint behind. You don't need to lubricate the O-ring groove. There will be enough grease on the O-ring.

If grease and dirt have built up in the O-ring groove, use the dampened edge of a paper towel. Add a small amount of dish detergent to the water, and make sure the towel isn't dripping when you clean the groove. Dry the groove with a clean towel and inspect it for lint.

Cleaning and Greasing the Main O-Ring

If the main O-ring is gummy with old grease and dirt, wash it with water and detergent. Gently wipe it dry with a soft cloth. To lubricate an O-ring, apply a small amount of O-ring grease to your fingertips. Then rub the grease over the O-ring's entire surface. When replacing the O-ring, check for hair. Human (and cat) hairs have flooded many a Nikonos.

• • • ————————————————————————

The procedures for removing and cleaning O-rings, and cleaning O-ring grooves and sealing surfaces, also apply to O-rings on lenses, strobes, flash connectors and other equipment.

———————————————————————— • • •

Caution: The main O-ring on the backdoor of the RS should be cleaned and greased after *every* dive. Use only non-silicone "Nikonos O-ring grease" for the Nikonos V and RS. Grease containing silicone should *never* be used on RS O-rings.

A hair (human, cat or dog) crossing an O-ring can cause a flood. How do I know? I've done it!

How Much Grease

Use only enough grease to lubricate the O-ring and its sealing surfaces. Excessive grease only holds sand and dirt particles. A properly lubricated O-ring will appear shiny, without visible globs of grease. O-ring grease doesn't form the water-tight seal; O-ring grease allows the O-ring to work smoothly against its sealing surfaces, and prevents abrasion when equipment is opened and closed.

How Long Do O-Rings Last

How long will an O-ring last? I don't know for sure. Some authorities suggest replacing O-rings yearly. I have functioning Nikonos III cameras with their original O-rings. Yet, I've seen

How much grease do you put on an O-ring? It depends on whom you ask. This is the amount I use for a Nikonos V main body O-ring. With the Nikonos RS, I use about 50 percent more.

"mysterious floods" that may have been caused by flattened O-rings. Thus, to be on the safe side, it's best to replace O-rings at least once a year. For those hidden O-rings you can't service, send your camera equipment to a camera repair service that specializes in Nikonos repair.

● ● ● ──────────────────────────

When storing their equipment, some underwater photogra-phers remove the user-serviceable O-rings from camera bodies and strobes, and the protective caps from sync cord connectors. Their goal is to prevent flattened O-rings.

────────────────────────── ● ● ●

CLEANING THE CAMERA BODY

Keep a small paintbrush in a plastic baggie. Use the brush to sweep lint and flecks of film emulsion from the inner camera body. Air blowers could force dust inside delicate mechanisms, so I don't use canned air or blower brushes.

To remove grease from the film pressure plate, dampen a paper towel or soft cloth with water mixed with a small amount of dish detergent. Wipe carefully, and don't let water drip into the camera body.

Use a jeweler's screwdriver blade-tip to drop tiny amounts of Teflon or liquid silicone on the Nikonos V back latch mecha-nism, inside and outside. With the Nikonos RS, lubricate the swivel pin of the latch. If corrosion is present, use WD40. Wipe off the excess with a soft cloth or paper towel.

Clean the O-ring sealing surface of the lens mount insert by wiping it with a paper towel.

CLEANING THE FLASH SOCKET

With either Nikonos, the flash socket plug should be cleaned if you have been using a strobe or not:

1. Use a coin to unscrew the lid.

This is what happens if you don't clean and lubricate the flash socket plug. This can also happen to battery compartment lids, strobe cord fittings and any other removable part you don't service.

2. Pinch the O-ring off with thumb and fingertip.
3. Clean the plug and socket threads with a toothbrush.
4. Wipe the O-ring and threads with a paper towel or cloth.
5. Apply a thin coating of silicone grease to the O-ring, and to the threads of both plug and socket.

CLEANING THE NIKONOS V REWIND SHAFT

This is a simple procedure:

1. Raise the rewind crank.
2. Press the folded edge of a paper towel against the shaft.
3. Rotate the shaft against the towel.
4. Use the end of a toothpick to place a tiny dab of silicone grease on the rewind crank shaft.
5. Lower the shaft and rotate it to spread the grease on the hidden O-ring.

Camera Battery Problems

The symptom of battery failure is obvious: The built-in metering system of the camera doesn't function. However, the battery may still be good. Oxides may have accumulated on the battery and battery contact surfaces blocking the flow of electricity. In many cases, simply cleaning the battery and flash socket with a pencil eraser solves the problem.

Testing the Nikonos V Camera Battery

Testing a Nikonos V camera battery is easy:

1. Look at your wristwatch through the camera viewfinder. Press the shutter release button half way to turn on the LED display, and count the number of seconds until the LED turns off. If it turns off in less than 16 seconds, the battery is dying.
2. If the viewfinder LED fails to turn on (after three film advances to turn the system on), either the battery is dead, the battery contacts are dirty or the LED circuit isn't functioning.
3. Measure the battery voltage with a battery tester: The tester should read 3 volts. If the battery voltage falls to 2.75 volts or lower, the camera may not hold the 1/90 second shutter speed when set for A (automatic). The automatic control may seek a slower shutter speed, even if a strobe is attached and turned on. This can cause overexposure and/or double images. If the voltage falls below 2.7 volts, the shutter speed locks at 1/1000 second. All of your pictures will be dark.

● ● ● ─────────────────────────────────

If the Nikonos V battery fails, you can still use the camera for manual operation. Set the shutter speed dial to M90. The shutter will trigger at 1/90 second. A (auto) and the other shutter speeds are electronically controlled and can't be used.

───────────────────────────────── ● ● ●

CLEANING THE NIKONOS V
BATTERY COMPARTMENT

Many underwater photographers "forget" to clean and lubricate the camera battery compartment plug and O-ring. Seawater travels up to the O-ring and can corrode the O-ring sealing surface inside the battery compartment. Because cleaning a Nikonos V battery compartment is tricky, I'll give you a complete list of steps.

1. Use a coin (a nickel works well) to unscrew the battery compartment lid. Note: The lid will unscrew, but will remain in the socket. Grasp the lid with your fingernails and lift it out.
2. Use a thumb and fingertip to pinch the O-ring out of its groove.
3. Remove the battery (or batteries). Clean them with a paper towel or rough cloth.
4. Use a pencil eraser to clean the contacts inside the flash socket, and inside the battery compartment and lid.
5. Apply a thin coating of silicone grease to the O-ring and replace it in its groove.
6. Apply a thin coating of silicone grease to the O-ring sealing surface inside the flash socket and to the threads of the battery compartment lid.
7. Replace the batteries, plus side (where the writing is) up.
8. Press the lid into the socket. You may feel a slight click as it seats. Look at it; it should be square with the bottom of the camera body.
9. Use a coin to tighten the lid. Start with a one-fourth reverse turn (counter clockwise), then screw it in place (clockwise). You may feel it "click" in place. If you feel any resistance, stop. Remove the lid and try again.

TESTING THE
NIKONOS RS CAMERA BATTERY

Test the Nikonos RS camera battery as follows:

1. Look at your wristwatch through the camera viewfinder. Press the shutter release button halfway to turn on the LED display, and count the number of seconds until the LED turns off. If it turns off in less than 16 seconds, the battery is dying.
2. If the LED displays in the viewfinder blink, the battery needs replacement.
3. If the LED displays won't turn on, the battery is dead.
4. Measure the battery voltage with battery tester.

●●● ————————————————————————————

If the Nikonos RS battery fails, the camera can't be used. All functions are battery powered. Always carry a spare battery on dive trips.

———————————————————————————— ●●●

Use a pencil eraser to wipe oxides from the spring-like contacts of the Nikonos RS camera body, and all other battery contacts and terminals.

CLEANING THE NIKONOS RS
BATTERY COMPARTMENT

Open the camera back and battery compartment lid, and remove the battery. Gently clean the spring contacts inside the battery compartment and the contacts on the battery, with a pencil eraser. When replacing the battery, it only fits into the compartment one way.

TESTING NIKONOS V SHUTTER SPEEDS

To test the A (auto) shutter speeds:

1. Set the shutter speed dial for A. Set the aperture for f22 and aim the camera toward a dark area and trigger the shutter. You should hear two distinct sounds—clunk, clunk —which may be several seconds apart, as the shutter opens and closes.
2. Set the aperture wide open, aim the camera toward a bright area and trigger the shutter. You should hear a single clunk because the shutter opened and closed more quickly.
3. Press the shutter release button halfway to activate the A (auto) mode. Look inside the viewfinder and pan the camera from bright to dark areas. The shutter speeds indicated in the viewfinder should change.

To test the manually-set shutter speeds:

1. Look inside the viewfinder and press the shutter release button halfway to activate the LED display. Rotate the shutter speed dial. You should see the shutter speeds change as the dial turns.
2. Set for a shutter speed of 1/1000 and trigger the shutter. The sound of the shutter opening and closing will be brief.

3. Set for a shutter speed of 1/30 second and trigger the shutter. The sound of the shutter opening and closing will be significantly longer. Test with consecutive shutter speeds. You should be able to hear a difference with each shutter speed used.

TESTING NIKONOS RS SHUTTER SPEEDS

To test the A (auto) shutter speeds:

1. Set the shutter speed dial to A.
2. Set the aperture to f22.
3. Set the focus control dial to P (so you can trigger the shutter without focusing).
4. Aim the camera at a dark subject and depress the shutter release halfway.
5. The display should indicate a shutter speed of one second, or the "Lo" indicator may be blinking.
6. Trigger the shutter; you should hear the one-second opening and closing of the shutter.
7. Open to a wider aperture and aim at a bright subject. The shutter speed should be higher.

To test the manually-set shutter speeds:

1. Set the shutter speed dial to one second.
2. Set the aperture to f22.
3. Set the focus control dial to P.
4. Aim the camera at a dark subject and depress the shutter release halfway.
5. Trigger the shutter; you should hear the one-second opening and closing of the shutter.
6. Reset the shutter speed dial for 1/125 second.
7. Trigger the shutter; you should hear a much faster opening and closing of the shutter.

EXPOSURE METER ACCURACY

The accuracy specification for most sunlight exposure metering systems is plus or minus 0.5 EV (plus or minus one-half stop). However, a defective exposure meter may give readings that are plus or minus a full stop or more. Therefore, it pays to test your exposure meter's accuracy.

● ● ● ────────────────────────────
The following tests are based on Kodak's "sunny 16" rule. With an unobstructed sun behind you, and with the shutter speed set for the same number as the film speed, the correct exposure for an average subject is f16.
──────────────────────────── ● ● ●

TESTING THE NIKONOS V EXPOSURE METER

This procedure doesn't require film in the camera:

1. Set the ISO film speed for 64.
2. Set the aperture for f16.
3. Set the shutter speed for 1/60 second.
4. Stand so the *unobscured* sun is behind you.
5. Aim the meter at an average subject, such as your lawn.
6. Depress the shutter release halfway.
7. You should see only *the glowing 60* in the viewfinder.
Note: You can adjust the film speed dial until you see only the glowing 60. You can use this adjusted film speed (called an "exposure index") to fine-tune exposure meter accuracy.

● ● ● ────────────────────────────
If you can't find an "average subject" when testing your exposure meter, take a close-up meter reading off the unshaded palm of your hand. This should give a f22 reading (because your palm reflects one f-stop more light than an average gray subject).
──────────────────────────── ● ● ●

Check the tiny screws on viewfinder shoes, close-up kits and other accessories. They frequently work loose with use.

TESTING THE NIKONOS RS EXPOSURE METER

This procedure doesn't require film in the camera:

1. Set the ISO for 64. (See "Setting the ISO for Non-DX-Coded Film," Chapter 17.)
2. Set the shutter speed for 1/60.
3. Set the aperture for f16.
4. Aim the camera at a subject of average brightness and reflectance, such as your lawn.
5. Depress the shutter release halfway. The analog exposure indicator should be close to zero.

Note: If you wish to zero the analog exposure indicator, adjust with the exposure compensation dial.

Care for Flooded Equipment

Let me refer to the advice of Fred Dion, Underwater Photo-Tech (a Nikonos repair facility):

1. Remove the battery and film.
2. Flush with fresh water as soon as possible (distilled if available).
3. Blow dry with hair dryer on low.
4. Continue working the camera shutter while drying.
5. Seal the camera in a plastic bag and get it to a repair facility.

··· *26* ···

MAINTAINING LENSES

Some underwater photographers check and clean their camera bodies carefully, but totally ignore the camera lens. To complete your camera maintenance, follow the steps in this chapter.

LENS MAINTENANCE CHECK LIST

The basic lens maintenance check list is similar for all Nikonos V and Nikonos RS lenses.

1. Test the aperture control.
2. Test the focus control.
3. Test the zoom control (RS 20-35 zoom).
4. Test the bayonet mount (V).
5. Clean the lens O-ring.
6. Clean the rear lens element.
7. Clean the front lens port.

TESTING NIKONOS V LENS APERTURE CONTROLS

Before, during and after each trip, verify that the aperture control actually makes the aperture larger and smaller. Remember: f22 is a small opening; f2.5 is a wide opening.

1. Remove the lens from the camera body.
2. Look through the aperture as you rotate the aperture control knob.
3. The aperture should change when the knob is rotated.

You shouldn't be able to turn the aperture past the extreme settings. If so, the lens needs repair. Note: All Nikonos V lenses—except the 28mm lens—have click stops that indicate each f-stop on the aperture scale.

TESTING NIKONOS RS
LENS APERTURE CONTROLS

The RS lenses don't have an aperture control on the lens, so you can look through these lenses to see the aperture change. The test procedure is as follows:

1. With the lens on the camera, look into the viewfinder. See if the aperture display changes as you change aperture.
2. Set the aperture for f22, focus for P and shutter speed for B.
3. Look into the lens port and trigger the shutter. You will see the aperture change to f22.

TESTING NIKONOS V
LENS FOCUS CONTROLS

Just because the focus knob turns, and the depth of field indicators move on a 35mm or 28mm lens, doesn't mean that the focus control is engaged. If you forced the focus control past the extremes of infinity and minimum focus, the internal parts could disengage. The focus could be locked at infinity, minimum focus or somewhere between, regardless of what the focus scale indicates.

1. Lay the lens face down on a table top.
2. Look at the retaining ring at the rear of the lens.
3. Rotate the focus control knob. You should see the retaining ring and glass element rise as you adjust toward infinity, and lower as you adjust for minimum distance.

This test works with the Nikonos I to V 35mm, 28mm, 20mm and 15mm lenses. With the 15mm lens, the movement is slight. If you don't see movement, the lens needs repair.

TESTING NIKONOS RS
LENS FOCUS CONTROLS

With the lens mounted on the camera, watch the image in the viewfinder sharpen as you focus by depressing the shutter release button halfway. You can also set for P (power manual focus), look inside the front lens port, and watch the lens elements move behind the port.

TESTING THE RS
20-35MM ZOOM CONTROL

With the lens mounted on the camera, look in the viewfinder. Turn the zoom control and watch the picture area change.

TESTING NIKONOS V
LENS BAYONET MOUNTS

Locate the two flanges, at the rear of the lens, that lock into the camera body. Locate the four screws at the rear of the lens mount. These are what we will be checking.

1. Hold the lens body and grasp the two flanges. Gently pull the bayonet mount away from the lens body. It should pull out about about 1/8 inch, smoothly.
2. With the exception of the 20mm lens, you should be able to see the guidepins and spring-loaded screws in the gap between the rear lens mount and the main lens body. You shouldn't be able to see any corrosion on the guidepins or spring-loaded screws.
3. If you see corrosion on the guidepins or screws, the inner lens mount must be detached so the corrosion can be removed. Send it to a repairman for cleaning.

The small screws that hold the bayonet mount of a Nikonos V can work loose with use. Check them for tightness (finger-tightness, that is).

Cleaning Lens O-Rings

All lenses. The procedure for maintaining the main lens O-ring, or the O-ring of an extension tube, is basically the same as for maintaining the camera back O-ring.

1. Squeeze the O-ring off with thumb and first finger.
2. Clean the O-ring and its groove with paper towel or cloth.
3. Grease the O-ring lightly with Nikonos O-ring grease and replace it.

Cleaning Lenses

All lenses. The only lens surface you normally clean on any Nikonos lens is the rear lens element. You can purchase liquid

The retaining screw of the Nikonos close-up outfit is a weak point. Unless it is rinsed and lubricated after use, it can freeze up. Turn it too hard to free it, and it breaks.

lens cleaner and lens tissue at camera stores, or you can purchase a *special lens-cleaning cloth*. Lens cleaning isn't preventive maintenance. Only clean a lens when it is dirty.

• • • ───────────────────────────────────────
You can use a blower brush to remove dust particles. However, you must keep this brush clean. If the brush was used to clean the camera body, it may have silicone grease on its bristles.
─────────────────────────────────────── • • •

If you accidentally get silicone grease on the rear element, it may not wipe off with cleaning cloths or lens cleaner and tissue. You can use water and dish detergent as follows:

1. Mix a drop of dish detergent in a few ounces of water.
2. Dampen a Q-tip or a piece of lens tissue in the detergent mixture.
3. Gently wipe the grease off the lens.
4. Dampen a Q-tip or piece of lens tissue in pure water.
5. Gently wipe the detergent mixture from the lens.
6. Dry the lens with clean lens tissue or a lens cleaning cloth.

Lens ports. Clean the front lens ports with water and detergent, and dry with a soft cloth. Leave the lens on the camera when cleaning the front port. If off camera, make sure the rear lens cap is in place.

···*27*···

MAINTAINING STROBES

*Strobes, connectors and nicads require as much main-
tenance as camera bodies. Cleaning and greasing O-rings
and their grooves is the same as with camera bodies.*

STROBE MAINTENANCE CHECK LIST

The following check list applies to most strobes. You can, of
course, modify the list for your specific equipment.

1. Clean all user-servicable O-rings.
2. Clean cord connections.
3. Clean arms and brackets.
4. Charge nicads.
5. Cure nicad memory.
6. Nicads vs. alkalines.
7. Condition the capacitor.
8. Test for synchronization.

CLEANING THE O-RINGS

The user-serviceable O-rings of the strobe and strobe connec-
tors require the same basic servicing as the O-rings of a camera
body:

1. Use a thumb and finger to squeeze O-rings out of
 grooves.
2. Use the folded edge of a paper towel to clean O-ring
 grooves.
3. Wipe all O-ring sealing surfaces clean.

Use your thumb and first finger to squeeze sync cord O-rings out of their grooves.

4. Use fingertips to apply small amounts of silicone grease to O-rings.
5. Look for flattened O-rings (see: "How Long Do O-rings Last" in Chapter 25.

CLEANING CORD CONNECTIONS

I use two toothbrushes: one for cleaning greasy threads, and a second toothbrush for cleaning the contacts at the ends of the cords. Don't leave cord connectors attached to the strobe or camera body for long periods of time. Otherwise, the threads can "freeze" in place. I detach and clean the connectors at the end of each day's diving, and apply a tiny amount of silicone grease to the threads.

●●● ─────────────────────────────

A sync cord can take only so many flexes before the wires inside the cord break down. If the strobe system requires that cords be bent at right angles, watch out! The life of the cord will be shortened. Always take a spare cord on expensive trips.

───────────────────────────── ●●●

CLEANING ARMS AND BRACKETS

Baseplates, arms and brackets often have user-removable nuts and bolts that can hold salt water even if the equipment is washed and soaked. Therefore, loosen all fittings and flush them out. Apply a tiny amount of silicone lubricant to threaded parts before reassembling.

Oxides and corrosion can form quickly if you don't wash arms and brackets after diving. Whenever possible, loosen fittings for rinsing.

CHARGING NICADS

Most nicad cells require about 10 to 12 hours to recharge, but quick-charge varieties may recharge in one to three hours. Two sets of nicads (one in use as the second set is being charged) are usually needed if you are making repetitive photo dives. And for live-aboard trips offering up to five dives a day, additional sets may be necessary.

● ● ●

For best results, don't charge nicads until the strobe recycle time becomes longer than normal. You can leave the strobe on and flash it occasionally to run the battery down. Don't run nicads down completely! One or more cells can reverse polarity and be damaged.

● ● ●

Continued overcharging can shorten a nicad battery's life. What often happens is that the user shoots 36 shots and then puts the battery on the charger for the full charge time; or worse, puts it on charge and forgets about it.

● ● ●

Because nicads function best when used frequently, and are significantly more expensive than disposable batteries, nicads are best for photographers who take pictures frequently. New nicads, or nicads that have been in long-term storage, give better results after two or three charge/discharge cycles.

● ● ●

CURING NICAD MEMORY

Some nicads "remember" short charge and discharge cycles. For example, suppose a battery is designed for 120 flashes, and has a recharge time of two hours. However, assume that the user repeatedly shoots 36 exposures and then gives the battery a 30-minute charge. The battery now "remembers" that it must only power 36 flashes before each 30-minute recharge. The battery

now resists accepting a full 120-flash charge. It has developed *nicad memory.*

To break the nicad memory pattern, fully charge and fully discharge the battery three times. When recharged for the fourth time, the battery will deliver its best performance. *Because of age and deterioration, however, performance may not equal advertised specifications.*

● ● ● ───────────────────────────────────

To discharge nicad cells, some photographers leave the strobe turned on for a few hours, flashing it periodically, until the recycle time increases. Others place nicad cells in a flashlight to run them down. If you have electrical skills, you can make a homemade discharger with resistors and/or a small light bulb.

─────────────────────────────────── ● ● ●

Some writers and engineers say nicad memory may have existed in the past, but doesn't exist with modern nicads. I believe memory varies from brand to brand. In my experience, occasionally fully discharging and recharging nicad batteries three times seems to improve nicad performance.

Nicads vs Alkalines

Nicads recycle strobes faster than alkaline cells, and maintain the shorter recycle times until the nicads are exhausted. This is great, because a long recycle time is annoying. This is bad, because a constant recycle time doesn't give any warning as the nicads approach exhaustion.

If you use disposable batteries, make sure that the word "alkaline" appears on the cell. Regular carbon-zinc flashlight batteries (even if marked "Heavy Duty") will not power a strobe for long. Alkalines offer several advantages when compared to nicads.

- Alkalines are less expensive.
- Alkalines usually power more flashes than nicads.

- Increased recycle time gives an indication of battery life.
- Alkalines can be tested with a battery tester.
- Alkalines don't require battery chargers.
- Alkalines don't have memory problems.

Although alkalines are easier to use (for the above reasons), they have disadvantages.

- The longer recycle times (as the batteries weaken with use) can quickly reach 10 to 15 seconds, or more.
- You must carry a heavy, bulky supply of batteries on lengthy dive trips.
- For frequent use, alkalines cost more per flash than nicads.

When buying alkalines, consider buying the least expensive brand. While the more expensive brand may offer a greater number of flashes, I usually change alkalines after 72 shots (two rolls) because the recycle time becomes too long. If you only use the "top" half of the charge, why pay for extended battery life you won't use? Also, if you rotate two sets of alkalines when taking lots of pictures, alkalines tend to rejuvenate with a rest period.

● ● ●

Alkalines are the better choice if you only use your strobe a few times a year. The partially exhausted batteries can still be used in portable cassette players, etc., after use in your strobe. Note: At this writing, chargers for recharging alkalines are appearing on the market.

● ● ●

CONDITIONING THE CAPACITOR

When a strobe hasn't been used for several months, the capacitor loses some of its ability to accept and hold a charge from the battery. If you use nicads, you might not get as many flashes as expected. If you use alkalines, the recycle times may be longer than normal for the first several flashes.

This is what you should see if your camera body and strobe pass the synchronization test. The entire paper target should be visible during brief flash of light from the strobe.

● ● ● ─────────────────────────────────

Think of the capacitor as a "muscle." The more it is used the stronger it gets; the less it is used, the weaker it gets.

─────────────────────────────────── ● ● ●

If you use alkalines, save a used set. Before using your strobe (assuming that it has been in storage for several months), insert the used alkaline cells and turn the strobe on. Let it "idle" in the ON mode for at least an hour. Now that the old alkalines have conditioned the capacitor, insert the new alkalines (or freshly charged nicads) and go take pictures. When you are finished taking pictures, turn the strobe off with the ready light glowing. This leaves a charge in the capacitor.

TESTING FOR SYNCHRONIZATION

This procedure can be used with either the Nikonos V or the Nikonos RS.

1. Attach the strobe to the camera with the sync cord.
2. Set the shutter speed for a speed at which the shutter and strobe should synchronize (try 1/60, for example).
3. With no film in the camera place a piece of white paper beneath the presure plate. Be sure not to touch the film advance sprockets with the paper or they will jam. Close the camera back.
4. Remove the lens and aim the strobe at the shutter curtain (through the front of the camera body).
5. Look at the shutter curtain and trigger the strobe with the camera shutter release. (With the RS, set the focus mode to P so the shutter will trigger.)
6. When the strobe flashes, you should see the white paper completely exposed when the shutter opens.

If you only see part of the paper exposed, or none at all, the shutter is not in synchronization with the strobe. The camera needs repair.

If you are uncertain if you are seeing all the paper, mark a large "X" on the paper from corner to corner. Make this mark carefully with a pen, reaching through the front of the camera body.

PART
··· 7 ···

APPENDICES

···*A*···

GLOSSARY

"A" (auto). Aperture-priority automatic exposure. You manually adjust the aperture control, and the automatic exposure control automatically selects the shutter speed.

Alkaline battery. A long-life battery with an alkaline electrolyte. Although generally used as a disposable battery, chargers for alkaline batteries are available.

Angle of view (angle of acceptance, picture angle). The angle that the camera lens "sees." Usually measured diagonally from corner to corner.

Apparent distance. The distance at which objects appear to be underwater. You see underwater objects one-fourth closer than they really are.

Apparent image. The image your eye sees underwater. (See "apparent distance.")

Aperture. The width of the iris opening that allows light to pass through the lens. The widths of these openings are expressed in f-stops.

ASA. American Standards Association. See "film speed."

Autofocus. A built-in system that automatically selects the correct focus (distance to the subject).

Automatic exposure control ("A"). The exposure is controlled automatically by a built-in exposure metering system. With the Nikonos V and RS, you manually select the aperture; the camera automatically selects the shutter speed.

Backscatter. Light reflecting back to the camera lens from suspended particles in the water.

Bracket. (1) To take a series of pictures at various exposure settings, such as f5.6, f8 and f11, covering both sides of your meter reading. One of the exposures should be correct. (2) To vary any other control, such as shutter speeds, film speeds or strobe-to-subject distances.

Camera slave flash. A special feature that allows strobe to

trigger the camera shutter when the slave strobe flashes.

Center-weighted metering pattern. The exposure meter reads mostly from the center of the picture area. With the Nikonos RS, for example, 75 percent of the sunlight meter reading is from the 12mm circle shown in the center of the viewfinder. With TTL, all of the TTL meter reading is within the circle.

Close focusing (macro) lens. A lens that can be focused from infinity to a few inches, with reproduction ratios of 1:2 or 1:1.

Close-up lens. A supplementary lens mounted in front of the camera lens to reduce the minimum focused distance.

Contrast. The brightness range from the darkest to the brightest areas within picture area. High-contrast scenes have a broad brightness range; low-contrast have a narrow brightness range.

Depth of field. The area in front of the camera—from a minimum distance to a maximum distance—in which your subject will be acceptably focused.

Diffuser. A curved plastic disc placed over a strobe reflector. The diffuser widens the strobe's beam of light.

Effective f-stops. The actual f-stop value when you place an extension tube between a lens and camera body, or when you focus a close-focusing lens for extremely close distances.

Exposure. (1) The amount of light striking the film when a picture is taken. (2) The act of taking a picture; for example, to "make an exposure."

Exposure compensation. To adjust the camera metering system to give more or less exposure. On the Nikonos RS, you can use the exposure compensation dial. With the Nikonos V, you can vary the film speed dial setting.

Exposure meter. A device, either built into the camera or as a separate accessory, which measures the amount of light available for an exposure.

Exposure table (strobe table). A table showing the f-stops for strobe exposures at various distances and power settings.

Exposure value (EV). As used in this text, a change in exposure equal to one f-stop.

Extension tube. A tube placed between a Nikonos camera body and the lens. The tube reduces the focused distance to less than

one foot.

Film speed (ASA or ISO). A number indicating how much light a film needs for proper exposure. The film speed number is usually included in the name of the film.

Fisheye lens. An ultra-wide angle lens with an angle of view of 120 degrees or more.

Flashmeter. A special exposure meter that measures the light output of a strobe.

F-stop (f-number). A specific aperture. As examples: f5.6 or f8, or any fractional stop between f5.6 and f8.

Focal length. The distance from the optical center of the lens to the film plane when the lens is set to infinity. For practical purposes, focal lengths give an indication of angle of view.

Focus. The adjustment for camera-to-subject distance. A picture taken with proper focus will have optimum sharpness at the focused distance.

Fractional f-stop. Any setting in between the full f-stops marked on the lens aperture scale.

Format. The dimensions of the image recorded on film. For example, the 35mm format (the width of the film) produces a 24 x 36mm image area.

Framer. A wire frame attached in front of the lens when you are using the Nikonos close-up outfit or extension tubes. The frame shows the picture area.

Guide number. A guide number is the product of aperture times distance. For example, if the f-stop is f8 at 10 feet, the guide number is 80 (8 x 10 = 80). You can divide the guide number by the f-stop to find the distance, or you can divide by the distance to find the f-stop.

Image ratio. The ratio between the size of the subject's image on film and the subject's actual size. For example, an image ratio of 1:6 (pronounced "one to six") means that the subject's image on film is one-sixth of the subject's actual size.

ISO. International Standards Organization. See "film speed."

Latitude (film latitude). The maximum amount of exposure error that can occur without seriously over- or underexposing film. For example, ISO color slide film has an exposure latitude of plus or minus one-half f-stop.

LED (light-emitting diode). Electronic displays in the camera viewfinder that show shutter speeds and other data.

Macro lens. See "Close-focusing lens."

Manual exposure control. Both the aperture and shutter speed are set manually, even if you are using a built-in exposure meter.

Master strobe. A strobe that is used to trigger a slave strobe. Any strobe can be used as a master strobe.

Matrix flash fill. A feature of the Nikonos RS. The TTL strobe automatically balances the strobe light in the foreground with the sunlight background exposure.

Matrix metering pattern. A feature of the Nikonos RS. The automatic exposure control reads the light values in five segments (upper left, upper right, center, lower left and lower right) and calculates the proper exposure.

Nickel-cadmium (nicad, ni-cad). A rechargeable battery commonly used to power strobes. Nicads usually last for 500 or more charge-and-use cycles.

Normal lens. A lens with an angle of view that approximates that of the human eye.

Parallax. The difference between the line of sight of an accessory viewfinder and the camera lens. These lines of sight should meet at a predetermined or preset distance in front of the camera.

Picture angle. See "Angle of view."

Recycle time. The amount of time it takes a strobe to charge up between flashes.

Ready light. A light, on the strobe and in the viewfinder display, that turns on when the strobe has recycled.

Rear-curtain synchronization. At slow shutter speeds, down to one second with the Nikonos RS, the strobe flashes just before the shutter curtains close. This is a special effect technique.

Relative f-stops. The f-stops marked on the aperture scale., as opposed to "effective f-stops".

Reproduction ratio. See "Image ratio."

RS (reflex system). In this text, "RS" refers to the SLR (single-lens reflex) feature of the Nikonos RS camera.

Selective metering. You select that part of the subject area which you wish to fall within the exposure meter's sensing area.

Shutter speed. The length of time the film is uncovered for an exposure.

Silhouettes. Dark shapes and figures against light backgrounds.

Slave strobe. A strobe that flashes when its built-in slave sensor detects the flash of light from another (the "master") strobe. A switch on the strobe allows you to turn the slave sensor on and off.

SLR (single-lens reflex). When you look into the camera viewfinder, a mirror directs your line of sight through the camera lens. At the moment the shutter is triggered, the mirror swings up so the film will "see" the subject through the camera lens.

Strobe (electronic flash, speedlight). A battery-powered electronic device that delivers a brief burst of light.

Strobe fill. Strobe light that is weaker than sunlight.

Synchronization (synchronization speed). The fastest shutter speed which allows the film to be completely exposed to the brief flash of light from a strobe.

TTL (through-the-lens). A strobe exposure system that measures the amount of strobe light passing through the lens and striking the film. When enough light has struck the film, the TTL system turns the strobe off.

Wide-angle close-ups. Close-ups taken with a Nikonos 20mm or 15mm, or a Nikonos RS 28mm, 20-35mm or 13mm lens. In each case, the lens is usually set for the minimum focused distance.

Wide-angle lens. A lens with an angle of view wider than the angle of view of the human eye. For Nikonos underwater photography, lenses with focal lengths shorter than 28mm are wide-angle lenses. The shorter the focal length, the wider the angle of the lens.

Zoom lens. A lens that allows you to change the focal length (such as the RS 20-35mm zoom lens). Changing the focal length changes the angle of view.

··· *B* ···

SOURCES

AB Sea Photo
(Equipment, rentals)
9136 S. Sepulveda Blvd.
Los Angeles, CA 90045
(310) 645-8992

Aggressor Fleet
(Jim Church photo courses)
P.O. Drawer K
Morgan City, LA 70381
(800) 348-2628

Blue Water Photo Lab
(Color prints from slides)
P.O. Box 20420
Atlanta, GA 30325
(404) 352-2191

Camera Tech
(Nikonos repairs, rentals, sales)
1817 Balboa St.
San Francisco, CA 94121
(415) 387-1700

Helix
(Miscellaneous equipment)
310 S. Racine St.
Chicago, IL 60607
(800) 33-HELIX

Jim Church
6744 Crooked Palm Terrace
Miami Lakes, FL 33014
(305) 824-1833

Ikelite UW Systems
(Strobes, miscellaneous equipment)
50 W. 33rd St.
Indianapolis, IN 46208
(317) 923-4523

Nikon, Inc.
1300 Walt Whitman Rd.
Melville, NY 11747-3064
(516) 547-4200

Nikon Repair Facility
(Nikonos repairs)
5355 Oakbrook Pkwy.
Norcross, GA 30093
(800) 645-667
(repair information)
(800) 645-668
(technical information)

Pacific Camera
(Nikonos repairs)
2980 McClintock Way, #H
Costa Mesa, CA 92626
(714) 642-7800

Sonic Research
(SR strobes)
P.O. Box 850
Bonsall, CA 92003
(619) 724-4540

Southern Nikonos Repair
(Bob Warkenton, repairs)
9459 Kempwood
Houston, TX 77080
(713) 462-5436

Spectrum Sea Color
(Color prints from slides)
P.O. Box 1736
Binghamton, NY 13902
(607) 723-8941

Technical Lighting Control
(Strobe arm systems)
629 State St., #222
Santa Barbara, CA 93101
(805) 962-2833

Ultra-Light Control Sys.
(Strobe arms, miscellaneous accessories)
92C Aero Camino
Santa Barbara, CA 93117
(805) 968-6611

Underwater Photo-tech
(Nikonos repairs, miscellaneous equipment)
16 Manning St., #104
Derry, NH 03038
(603) 432-1997

Battery
Radio Shack
Cat. No. 23-009
Silver Oxide 76
EPX 76
1.5 Volt

···INDEX···

A **bold** faced page number denotes a picture caption.